"We British folk are all [] We come from all over the place, we move all over the place, and our ideas are all over the place. This book reflects that. Here are pictures, and words, with a real sense of place. I love it."

BENJAMIN ZEPHANIAH, POET

First published in Great Britain in 2021 by

Policy Press, an imprint of Bristol University Press
University of Bristol, 1–9 Old Park Hill, Bristol, BS2 8BB, UK
t: +44 (0)117 954 5940 | e: bup-info@bristol.ac.uk

Details of international sales and distribution partners are available at
policy.bristoluniversitypress.co.uk

British Library Cataloguing in Publication Data
A catalogue record for this book is available from the British Library.

ISBN 978-1-4473-5405-5 paperback

Cover and text design by blu inc, Bristol

Bristol University Press and Policy Press use environmentally responsible print partners
Printed and bound in Great Britain by Cambrian Printers, Aberystwyth

Editor and Curator: Paul Sng
Assistant Editors: Peter Cary, Melissa Rose
Interview transcriptions: Jo Blair
Editorial Assistant: Lowenna Merritt

Cover Photographer: Rhys Baker

 invisiblebritain @invisiblebritain @invisiblebrit

www.invisiblebritain.com

INVISIBLE BRITAIN
THIS SEPARATED ISLE

"Our insignificance in comparison to nature is something we might all realise eventually as humans. That awareness within a community is damaging to often the most vulnerable people in society, leaving them with a sense of invisibility. By asking remarkable photographers from within those communities to create portraits of some who have felt overlooked, This Separated Isle *is an attempt to focus on those people, placing them centre stage so that we can see them and begin to understand their stories."*

JENNIE RICKETTS, INDEPENDENT PHOTOGRAPHY CONSULTANT

SUPPORTED BY

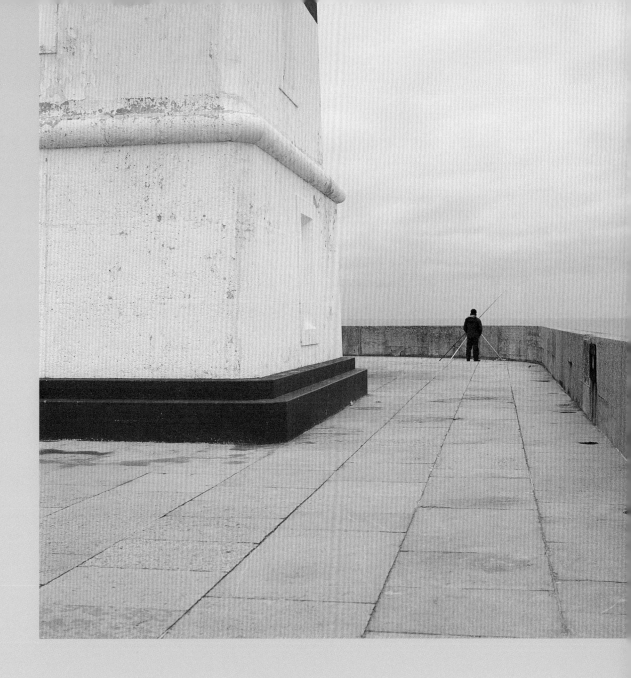

PHOTOGRAPHER: ROBERT LAW

"*As bleakly poetic and forlornly beautiful as its title suggests, there's very little I've seen recently that more encapsulates what an odd, fractured and divided little nation we've become — though with the potent flipside that the voices and images in this book represent mini beacons of hope in their quiet defiance and inspiring determination to build a better and braver world.*"

DANIEL YORK LOH, ACTOR AND DIRECTOR

ACKNOWLEDGEMENTS

This book would not have been possible without our Kickstarter supporters – thank you to each and every one of you. We would also like to thank the following people:

Adam An-Tathair-Siorai
Aidan Jay Brown
Alan Humphris
Alex Yates
Alexandru Badiu
Ali West-Scott
Alison Shaw
Amber Lanfranchi
Andrew Sherman
Andy Williams
Antonia Thomas
Barbara Weed
Bert Hogenkamp
Bluecoat Press
Caleb Yule
Calum Webb
Caron Wright
Charles Bell
Chris Routledge
Colin Wilkinson
Dave Worth
David Fletcher
Deborah Coles
Fiona Monsell
Freya Trand
Gair Dunlop
Gonzales Photo
Greg Hughes
Greg Turner
Heidi Alexander
Helen Goulden
Helen Yates

Ian McFee
James Brown
James McCauley
James Shortall
Jared Shurin
Jen Rose
Jessica Miles
John Wilson
Jonathan Henderson
Jonathan Warren
Josh Allen
Julie Brennan
Karen Davies
Kathryn King
Kenn Taylor
Kenny Brown
Kevin Williamson
Liz Tobin
Lorraine Mustard
Mary O'Hara
Mathilde Bertrand
Michael Laing
Muyang Song
Nicky Bird
Nicola Martin
Paul Wright
Paula Geraghty
Perry Emerson
Philip Holbourn
Rebecca Tomlinson
Richard Eyers
Robyn Elizabeth Gow

Ron Keogh
Ronald Ang
Rosanne Olley
Sebastiano Dell'eva
Steve Mallinson
Stuart Betts
Sue Southworth
Supercollider
Teresa Gore
Terry Gallagher
Thomas David Kavanagh
The Tish Murtha Archive
Tom Warburton
Tony, Christiane and
Niall Byrnes
William MacDougall

SPECIAL THANKS:
Chris Norbury
David Thorp
Elton Murphy
Hilary Morison
Ian Young
John Whte
Mark Payne
Richard Eyers
Richard Huw Morgan
Roeland Gevers
Stephen McKay
Valerie Sng
William Streek

FOREWORD

So many of the people in this book are unseen by a society that has become increasingly fixated on notions of its own history and identity

We are mixed-race children watching the Olympics. The 400-yard sprint. There's a White runner from Birmingham and one from Cork, a tall woman from Saint Kitts and a couple of African Americans. Who to cheer for? Who do we want to win? Who comes top in our allegiances? In other words, who are we? We've never met anyone with our exact racial mix, but we have one another, five of us. We're a tribe of our own and, in this respect at least, we are seen and understood. We are not invisible.

Then you grow up and the allegiances – the assumptions – are thrust at you: the vote, the passport, Brexit. You find that when you turn up for a job you are Black and when you are driving at night you are Black and when you challenge the neighbour you are Black. And sometimes you're a 'redskin' and not Black enough. When you speak you are working class, you are from the Midlands and therefore not 'Northern'. Your chewy accent means you are uneducated. And Irish, you say? 'Aren't they terrorists?' And so on and so on until being seen for who you truly are becomes a rarity and you're reduced to shorthand and convenience, code switching for all you're worth.

How we are identified and seen by others is, of course, all down to who those others are.

So many of the people in this book are unseen by a society that has become increasingly fixated on notions of its own history and identity, a society that wants to bask in the white light of its former glory while smothering any attempt to examine it too closely or at all. A 'pompous yet failing country . . . used as a blueprint for what the rest of the world must look like.'[1]

[1] TANATSEI GAMBURA, EDINBURGH, PAGE 24

And yet what we see in these photographs is beautiful: humanity at its most interesting, truthful and varied. Here is a 96-year-old Jewish man whose family came to live in the East End of London fleeing the pogroms. 'Being British', he says, 'was secondary to being Jewish, and being Jewish was secondary to being working class.'[2]

It's this multiplicity of identities that is so fascinating in this book. In each attempt to define their identity, the subjects reach for ethnic categorisations, class, job titles, language, family and even football clubs. We turn around and look back at our history and parentage, the often arbitrary decisions that made our fathers and grandmothers leave their homes and settle in Wales or Wolverhampton, Todmorden or Tower Hamlets. We look at our skin and the shape of our eyes and understand that, even without the labels and the passport, we will be judged on that alone. It's not enough to be Scottish or English unless you fully look the part.

So many of these photographs show people whose race it would be difficult to define by sight alone: the Polish Scot, the German girl from Glasgow, the Tibetan Londoner and the Swedish Indian, all of them living in Britain, aware of their difference and the way it is perceived. There's an uneasiness here, a sense of being under threat, very real threat in the case of Owen Haisley, who came within 20 minutes of being deported to a country he hadn't seen since he was four years old.

Even White British people feel they are invisible outsiders in a country with 'an underlying ugliness'[3] permeating the soggy soil. In this book, notions of separation, of an independent Wales and Scotland, are bound up with freedom and fairness. Class and economic power inevitably exert as much influence as race and ethnic identity, from migrants who come to Britain for a better life to those who only experience life as

having 'just got shittier', unable to look after their houses and 'just trying to exist'.[4] And the Brexit thing lies heavy and menacing over everyone: interrogated at immigration, looked at sideways, fields of unpicked fruit and an NHS doctor suddenly being 'othered' by the national discourse.

But there is resilience too. (Not that resilience is necessarily a good thing. While I am spending my emotional resources being resilient, what are you doing with your unattacked life? Getting ahead, no doubt.) The resilience shown by the people in this book is a kind of personal commitment to thrive: a determination to succeed and to self-care and to build community. The eloquence and very existence of the subjects of these photographs is a resistance to the invisibility they experience. Despite the forebodings of things getting worse, we also find hope on these pages and, for me, there is a visceral, tribal connection through difference and existing beyond neat, nationalist categories.

This Separated Isle is personal stuff. It's not only the subject that is examined but we, the readers, are being looked at and addressed. Black Lives Matter, climate change, Windrush, anti-Semitism, land access, gentrification, immigration, racism – it's impossible to read these narratives and not be moved to sorrow and anger and to ask ourselves what we are thinking, what we are doing.

While Britain talks up the Brexit emperor's new clothes, we have the opportunity to call out its colonial and imperialistic legacy, its suicidal adherence to class constructs and notions of who can and who cannot belong here. We can be the child with 20:20 vision who points and says 'But look! You are naked.'

KIT DE WAAL

[2] NATHAN FIELD, LONDON, PAGE 23

[3] CELESTE BELL, HASTINGS, PAGE 58

[4] SIMON TYSON, DEREHAM, PAGE 62

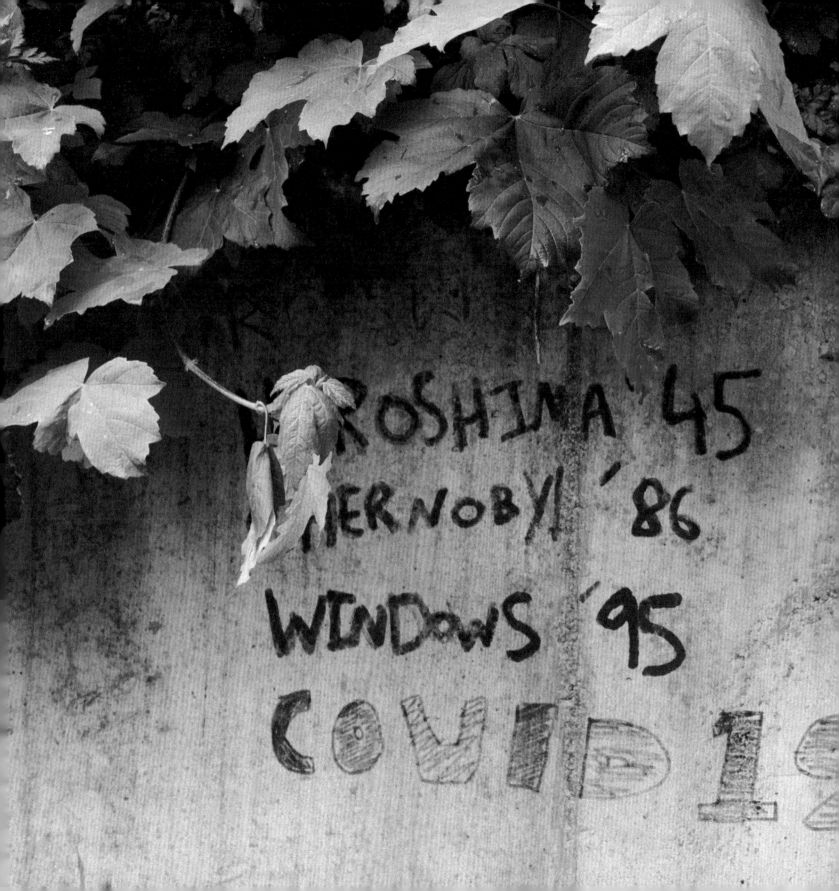

INTRODUCTION

London, 1982. I am five years old. A mixed-race only child in a single-parent family from a council estate in pre-gentrification Peckham. My understanding of what it means to be British is limited to patriotic clichés and caricatures. The Second World War ended more than three decades ago, yet for the dads and grandads and the boys waging war with plastic toy soldiers, victory over the Nazis still demonstrates how great Britain is. The cries of 'Two world wars and one World Cup' ring hollow to my young ears. Margaret Thatcher, mass unemployment and the miners' strike are to define my childhood more than past glories won in honour of the British empire. Great Britain is a mythical place that exists only in history books and old films.

I experience racism for the first time that summer during the school holidays. Marcus, an older boy at my childminder's house types the word 'CHINK' on the rubber keys of his ZX Spectrum computer, which then – as if by magic – appears dozens of times on the monitor screen. I will never forget that moment. It will come to define much of my childhood. The howls of laughter from the other kids. My impotent rage and burning shame as I run to the toilet, embarrassed and hurt, refusing to let them see my tears. I will remember the childminder's indifference and the whitewashing when my mum arrives to collect me: 'He got a bit upset. It was only a joke. You know what kids are like.'

From now on racism is a regular occurrence in my life. Sometimes it's directed spitefully and designed to injure me. Other times it happens in jest and as 'banter'. It always hurts. The insults are mostly verbal. The abuse is sometimes physical. On one occasion, my assailant smashes a chair over my head, which requires a visit to the hospital for a few stitches. Whichever way it comes, the impact is always violent. The bruises heal, but the mental scars always remain.

Growing up bi-racial and working class during the 1980s in Britain is horrendous for me. The few happy memories I have stick in my mind like postcards pinned on a board. I struggle with my identity and find it difficult to accept my ethnicity. I don't fit in with the White kids at school, and the other groups of non-White kids seem to bond together over a shared heritage that excludes a half-White, half-Chinese kid like me. Like most children, I crave a sense of belonging. I decide that means being White. It doesn't work; I am still seen as other, as yellow – a chink and a ching-chong Chinaman.

Mum encourages me to be proud of being mixed race and is active in her attempts to introduce me to Chinese culture. It isn't easy for her – she left my dad when I was two and I see him once a week, on a Sunday. His lifestyle is alien to me. I despise the long walks in the countryside and the strange, spicy food he forces me to eat afterwards. I resent the strict discipline and his insistence that I obey a set of rules that contradict many of the values mum instilled in me. To hell with being Chinese. As far as I am concerned, I am English. I like English food, I wear an England football kit and I even try to join in when other kids are racist towards non-White kids. But, still, I am not accepted. To the White kids, I am a half-breed, a mongrel – not as pure as them. There isn't a single person of east or south-east Asian descent in my primary school. I stand out, despite my intense efforts to blend in.

Mum continues to do her best to help me accept who I am. She never gives up. She tells me that my Chinese middle name means 'golden hero' and that being mixed race makes me special. One day, with the help of a Chinese astrology book, she tells me I was born in the year of the dragon, in the hours of the dragon, and that my elemental sign is fire – a rare and lucky combination, apparently. She tells me about Bruce

Lee and we watch *Enter the Dragon* together. He becomes my hero and I learn Wing Chun kung fu to defend myself against the bullies.

When I arrive at secondary school, there are other kids who look like me. Not many, but enough for me to be less alone. There is a wider range of ethnicities and more cohesion between the different groups of non-White kids. Over time, the racist abuse here will feel different, less threatening. I am accepted as part of the gang by the White kids, though I'm never quite one of them.

I am still an outsider. But I'm beginning to accept who I am.

PAUL SNG, JUNE 2021

Kristie de Garis
Perthshire

We're 96 per cent White and I believe we aren't experiencing quite the same problems as elsewhere simply because there isn't the same tension.

My grandfather came to Scotland from Pakistan after the Partition. I never remember what year it was – nineteen forty-something. He was one of the first Pakistani immigrants to settle in Glasgow. Scotland had said something like, 'You're welcome here, come here.' That's why he came. He met my grandmother in Glasgow. Most unlikely couple of all time: a six-foot-something, incredibly brown, Pakistani man and a wee, blonde-haired, blue-eyed, Norwegian–Irish woman.

Mixed-race couples weren't very tolerated in Glasgow at that point. They had six children and had a really hard time. There were gangs. My uncles were stabbed. There was violence constantly. It was an incredibly stressful, painful upbringing and it was like that the whole time: racial violence. It seriously affected the whole family and they left Glasgow and moved to West Lothian, where I was born. It still affects them.

Most people assume I'm White. I would describe my ethnicity as mixed race. I am Scottish and Pakistani. If someone casually asked me where I'm from, I would say I'm Scottish. I was born in Scotland. I've lived here my whole life. I'm light-skinned and I grew up being treated like a White person. After what my family went through, I do feel an enormous sense of guilt that I had that opportunity. I could just blend in if I wanted to, and I did until I was much older. I was very unthinking about race until my late twenties. When I started openly speaking about it and describing myself as mixed race, I got a sense of not belonging. That felt crazy because I did belong, and all of a sudden there was this shift. I learned very quickly that it did change things. I know a lot of people would disagree with this, maybe say I was anticipating it or I imagined it. But, no, I felt the shift.

I think Scotland is exceptional for many reasons. I love living here, I feel very connected to the land and I love what's happening politically. But in Scotland you can go for days without seeing a Black or brown person. Especially where I live, rurally. The cities are more diverse, of course, and last time I was in Edinburgh I loved seeing the assemblage of diversity. I felt at home, but it's nothing compared to cities like Manchester or London. We don't have anywhere near that level of diversity in Scotland.

You'll hear 'Scotland isn't a very racist country' a lot. I disagree. We're 96 per cent White and I believe we aren't experiencing quite the same problems as elsewhere simply because there isn't the same tension. There is little diversity or challenge to Scotland's Whiteness. I think Scots are really arrogant for thinking we've got the racism sorted. If our country was more diverse, I believe we would be seeing the same problems that we see elsewhere, like in England. The only reason my life in Scotland as a mixed-race person isn't difficult is because I have light skin. I exist in an interesting and privileged space where people accept me at face value because of my skin colour. This means that I experience Scottish society from the inside. And I can tell you we have huge issues with racism.

I don't think anyone could say that we haven't seen a rise in racist sentiment since the Brexit vote. I find the expression of this racist sentiment really scary. People and their racist ideas have become emboldened by this political climate. I've been in many situations where I am the only person who challenges racism. If there is one thing you can do, one thing you should do, it's challenging racism when it is in front of you. The truth is most people don't, and I get it: it's hard. Sometimes it's a lonely place to be – no one wants to be the one creating the awkward social situation. But it's the least you can do and it's absolutely necessary.

PHOTOGRAPHER: KIRSTY MACKAY

Jack Tully
Glasgow

We've taken steps backwards, not forwards, when talking about identity and difference. Britain seeks to return to some form of colonial nationalism, when Britannia ruled the waves.

When people ask me where I'm from, my answer hasn't really changed since I was about five years old. I'm from London and Scotland – not English or British. Scottish. I was born in north London: the Arsenal-supporting side. I lived there until I was 18. My mum grew up just outside of London and my dad grew up in Glasgow: the Celtic-supporting side. I've revelled in this fact since I was a boy and it's one of the reasons why moving back 'home' to Glasgow was always inevitable.

At my primary school in Haringey, over 50 languages were spoken. All religious holidays were celebrated, diversity promoted, differences unpacked and understood – ultimately a safe space where your identity was something to be proud of. Everyone's got a story and it was school where I felt safe to tell mine. I felt immense pride in my Scottish identity.

My Scottishness was also established through football. I've always supported both Arsenal and Celtic and I always made a point of wearing my dark blue Scotland shirt, the lion rampant clear for everyone to see. I remain 100 per cent committed to the age-old 'anyone but England' when the Three Lions are playing. I still have a picture on my wall of my first Celtic shirt, me and my great-uncle holding the shirt, name embossed on the back, like I was the new signing, him the manager. My identity is made up of many things, and like a lot of people my football teams are an important part of that.

It's not just football that makes me proud of my identity. I didn't spend much time with extended family growing up, but when I did it was filled with storytelling. Tales of my merchant seaman great-grandad, who went on to pilot ships down the Clyde. Stories of my great-aunty performing on the stage at the Citizens Theatre. My grandparents falling in love on the isle of Arran. They're my family's folk tales, little stories that I've repeated to my friends and that will no doubt be further embellished when I tell them to my own children.

The only time my Scottishness was attacked more than just as a joke about haggis or being shit at football was when I wore my Scotland shirt to a party when England lost to Portugal on penalties during Euro 2004. I wore it as a wind-up, but when an adult tells you as a ten-year-old to fuck off, you're going to remember it. I'm 25 now and this is the only incident I have ever dealt with where my identity was questioned and shouted down.

Celebrating my Scottishness has been easy. I'm a White guy. Ask this question of the Muslim boys in my class, or the Iranian family who lived next door, or the second-generation Jamaican family whose son I played football with, and you're going to get a different answer. We've taken steps backwards, not forwards, when talking about identity and difference. Britain seeks to return to some form of colonial nationalism, when Britannia ruled the waves and raped and pillaged its way across near enough the entire planet.

My experiences at school really shaped my world and local view. As has my mum, an activist and an anti-racist and feminist. I mention these two things specifically because from an early age I was made aware of the privilege my background lends me and the set of privileges and opportunities that are afforded to me purely because of the colour of my skin and gender. She taught me about the inequalities of our society and the horrors of British state-sanctioned violence and brutality at home and abroad. I was taught anti-imperialist and anti-colonial history by her and her friends and colleagues. I was lucky that my school selected British colonialism as the main topic for A-level history – something that should be included in all school curriculums from early years. These views inform the way I live my life and the work that I engage with.

When I moved to Glasgow I felt proud of my connection to the city. It's gone full circle, as I now live five minutes from where my grandfather's family first moved to in 1949. I've walked the same streets and uttered the same clichés. I've returned home.

PHOTOGRAPHER: CHRIS LESLIE

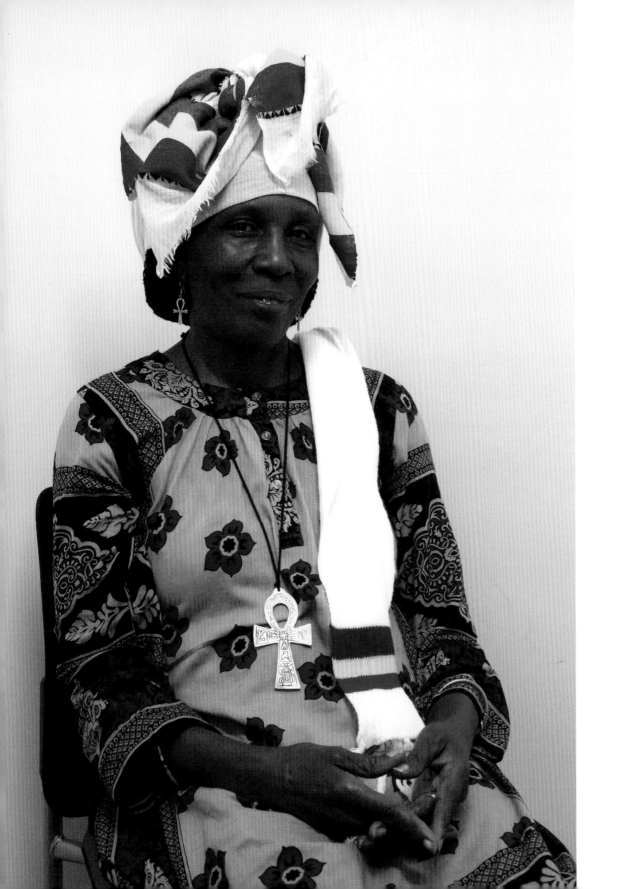

Empress Zauditu Ishuah
Birmingham

The whole of the British empire is based on – and has benefited greatly from – slavery. The historical perspective is deeply rooted in the system and is ingrained within UK society.

My parents both came from Jamaica to seek work back in the 1950s. I was born not long after they came. It was a time of great strain upon our people coming from the Caribbean to work here. I grew up in a mainly Black and ethnic minority community in Handsworth, Birmingham. It was a time of Black consciousness, and I was gaining more knowledge about myself as a Black woman living here in the UK. Growing up in this community helped shape that consciousness to gain knowledge about myself, my culture, and to develop skills. I became more interested in my African heritage. According to British categorisation, I would be African Caribbean, but first and foremost I am a proud Black African.

Inclusivity hasn't come naturally to British society. It hasn't been an organic process; it's been more reactive. If the government wanted inclusivity, it wouldn't have led to what happened with the Windrush generation. Hundreds of people from the West Indies were asked to come to the UK back in 1948 to work in the health industry, British transport, etc. Black people had to internalise forced enslavement, living in areas around the UK with poor housing, a lack of fresh fruit and vegetables and of medical resources to sustain that community.

The government seems to have turned its back on those who were given rights to remain in the UK. You only have to look at the recent spate of people being deported back to Jamaica, and the difficulty for some of us to prove our British nationality. Racism is still rife within our education system, our healthcare systems and other systems that govern the way society runs. We have an uphill struggle. We have to battle at all times.

As a nurse, I have known a number of people who have succumbed to COVID-19. I have lost family members and my own child recently due to a long-term condition. COVID has been affecting members of my community a lot more than other communities. We are living in areas which are highly populated and the air quality is poorer, pollution more common. There are high unemployment rates and other conditions which are widely known.

Recently, some government officials categorically stated that there is no racism in the UK. When you look back at history, I don't understand that statement. The whole of the British empire is based on – and has benefited greatly from – slavery. The historical perspective is deeply rooted in the system and is ingrained within UK society and institutions. It's going to take more than words to say that the UK is not racist when racism continues to exist and is integrated structurally in covert ways.

Black Lives Matter in the UK is asking the government to end racial discrimination, decolonise the curriculum and implement measures to safeguard children at risk of racial discrimination and bullying, as well as to investigate health disparities. These are things that obviously need to be addressed, but we need to look at the root of the problem. We're not addressing the root of the problem because we're always treating the symptom instead of the root itself. The root goes right back in history. Until certain stark realisations of the truth and admissions begin to unpick some of the serious damage that's already been done, racial injustice is always going to continue.

The BLM movement is like having a spot or a boil on your face that's festering and festering, but you only deal with it once it's burst. So the situation in relation to the demands of BLM is looking out for basic human rights for us as Black people. Our basic human right is a natural right – the right to life. I think what actually needs to happen is that Black people need to get together themselves to sort Black people's problems.

There's a lot of history that we ourselves as Black people need to be aware of in order to become who we truly are. The statues erected of former slave owners serve as a kick in the face to Black people. If you don't agree with what a historical figure represents because it's abhorrent, then why is that monument still there, being given reverence and glory? It's very hypocritical for the UK government to claim not to be racist but dotted all around the country are the remnants of that slave trade.

PHOTOGRAPHER: INÈS ELSA DALAL

Yassine Houmdi
Portobello

During the pandemic, we really struggled. At one point we couldn't find staff. At that point I realised how important immigrants are to the job market.

I was born in Morocco in a city called Essaouira. At university, I built up my knowledge of the world, and learned what's going on outside my country. I built the ability to critique. My country is conservative: there are many taboos, subjects we couldn't talk about. Learning how to break these taboos helped me define my personality and identity.

My wife, Lynn, and I spent nearly three years in Morocco together and we decided to have a kid. Lynn said it's better to come to the UK because it has more opportunities than Morocco. The health sector is brilliant and education here is better for our son. He's half-Scottish, half-Moroccan. Well, I think he's 70 per cent Scottish anyway, because he's born here, he lives here and he goes to school here. But his roots are also Moroccan. I'm really worried about him having to face racism. I don't want him to be confused about which community he belongs to.

I work in a care home as a senior carer. I can see the UK needs immigration because most of the carers in this sector, and even the chef in the kitchen, are immigrants. During the pandemic, we really struggled. At one point we couldn't find staff. At that point I realised how important immigrants are to the job market.

I believe in democracy and I believe if people voted for Brexit, then they want Brexit. I don't agree with the way politicians present Brexit as a solution. I think it is a big lie. They use immigration as an excuse – they say immigrants are the ones taking our money, our benefits. They use this to attract people to vote for them. But people should know these problems come from the politicians, not from immigration. They don't know what immigration brings to the country. The population of the UK is older – there are more old people than young people. Immigrants pay taxes to help the economy, which help to provide stability for older people after they retire. Politicians don't talk about that.

British society is diverse. Where I work, I see that, and I see that in the government as well; in Scotland you can see different ethnicities in government. There is diversity even in powerful places, and these people run the country. You can see more diversity in England than in Scotland because of its economy. In England there are big industrial sectors, so immigrants prefer to go to places where there is work. And in Glasgow there is more diversity than Edinburgh. For me, Portobello needs more diversity.

From my experience, the majority of British people are nice. Even when I was in Morocco working in hospitality, we always liked British customers because they were kind and easy-going and not grumpy – and, also, generous. I think the Scottish are more relaxed than the English.

In Morocco life is a bit harder than in Scotland. I come from a city where there is a beach, like Portobello. I used to swim in Morocco but here I had the opportunity to learn how to swim properly and in the open water for long distances. For me swimming is part of my life. The difference is the water here is colder, but that never stops me from swimming.

PHOTOGRAPHER: ALICIA BRUCE

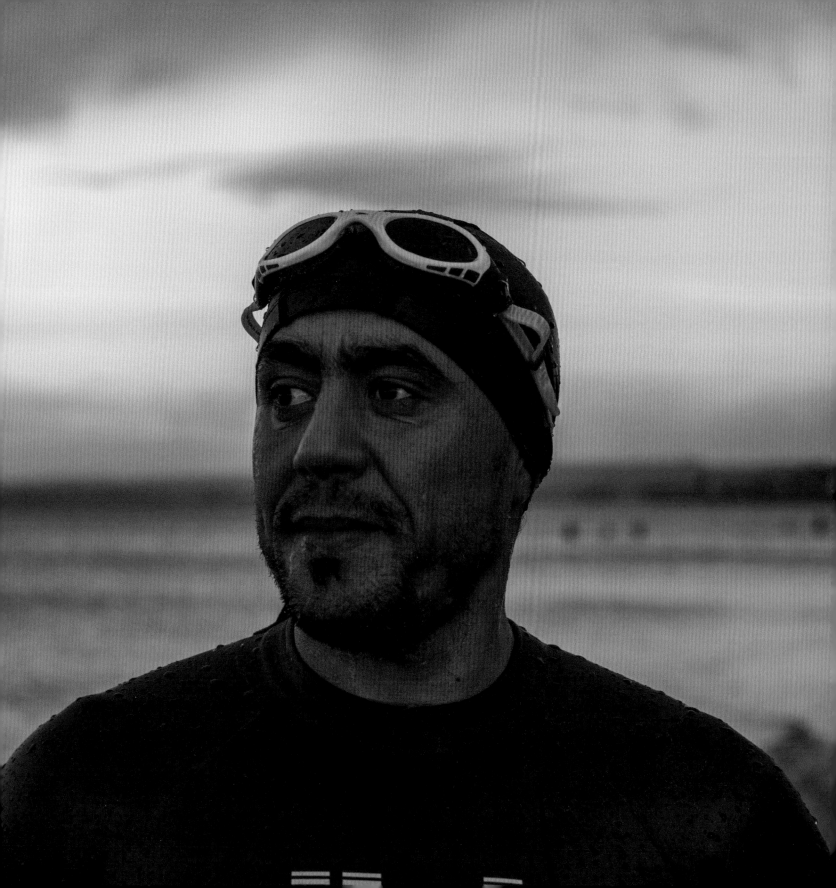

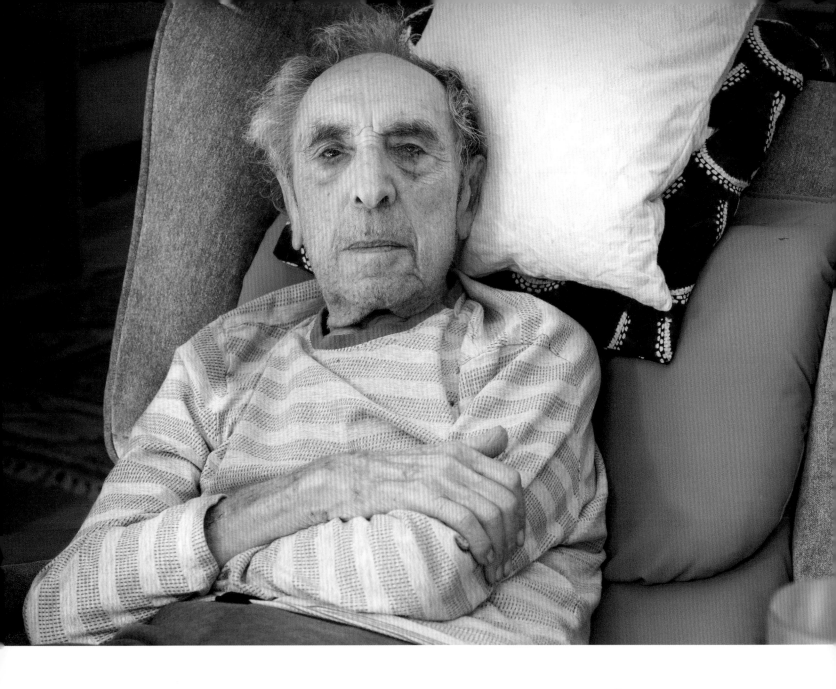

Nathan Field
London

Once again, populist ideology is trying to divide us. Them and us – I've seen where that goes. I am not optimistic any more, not since the Brexit vote.

My great-grandparents lived on the border of Poland and Russia. They came here as refugees fleeing the pogroms. My grandparents on both sides lived in East End of London, off Commercial Street. That's where both my parents grew up, in fact on the same street. When my father came back from the army he plucked up the courage to talk to my mother, I think he'd had his eye on her for a while!

Being British was secondary to being Jewish, and being Jewish was secondary to being working class. It was a lonely, sterile childhood till we moved. My very early years were spent down a miserable street in Mile End, where all the terrace houses were brown. We lived in a one-bedroom flat; my mother's ambition in life was to get back to the East End to her family in Whitechapel. I can vividly remember around the age of five standing by the window cleaner on the street, when kids came and chatted to me and invited me to play. In the middle of the road we set up a game throwing a ball at a can that was balancing on sticks. There were no cars in the streets then. A whole new life began – I realised I could have friends and they became friends for years and years. I spent hours playing in the street and sitting on the doorstep with my pals. When I went back about 20 years ago there were a group of Bangladeshi kids sitting on my old doorstep. I wonder who succeeded them? It's so gentrified that I can't imagine it would be immigrants now.

I remember, as a young lad about 12, I accidentally got caught up in the march of Mosley's fascist Blackshirts. I'm not sure how I was in the middle of the marchers, but I can still remember how scared I was that they'd identify me as a Jew. It was a week after the march in Cable Street and they had grown in numbers. I managed to slip down a side street and ran till I was home. They went on to attack Jews in Mile End and destroy Jewish businesses.

I haven't been a practising Jew for many years. In fact, for most my adult life I was interested in Buddhism. Of course, both being Jewish and being brought up working class in the East End of London have influenced me in ways it would be hard to distinguish. When I grew up, you were either Jew or Gentile (non-Jews) and everyone was White. My identity has shifted over the course of my life and I don't think of myself in these terms any more. It's more how others might identify me.

I've always felt that the most significant opportunity happened when I passed the eleven-plus and got into the grammar school. I knew it was going to change the direction of my life and maybe that's why I've never stopped learning. I eventually became a psychoanalyst. My father didn't have a choice – he was a tailor. He was also quite gifted at drawing, yet I don't think it occurred to him that he could have pursued something artistic. My mother was very bright and ambitious, but as a woman she could only fulfil herself through a man and I think she did that through me. She was very proud of me and pushed me to be a writer.

When I was able to leave the East End, I moved north to the suburbs like many Jews. Sometimes the Jewish world suffocated me, yet it's true that I lived in an insular community and had little awareness of or even interest in the experience of the immigrants that later came from the British colonies. I'm not anti-immigration at all. I would like to see Britain open its borders to people seeking refuge.

I'm 96 now. I hear the news and I am worried. Once again, populist ideology is trying to divide us. Them and us – I've seen where that goes. I am not optimistic any more, not since the Brexit vote. I hope the young are not as tired as me and will come together and stand against all those who want to separate us.

PHOTOGRAPHER: FIONA YARON-FIELD

Tanatsei Gambura
Edinburgh

The intellectual and cultural superiority of the British empire is a fiction, and the notion that it was built without the labour of immigrants is dishonest.

I was born in Harare, Zimbabwe, to a working-class family. My parents worked hard to give us a middle-class upbringing and were the first generation to do so because being working class in a developing nation is difficult, to say the least. I was exposed to a specific demographic growing up because my parents knew that the closer you are to Whiteness, the closer you are to the wealth.

I went to a majority White private school, a unique experience when you're living in a Black majority country. The White population is a minority in Zim. I think my parents had an understanding of what that meant for my ethnic identity, but the success of their children was more important, and conventionally that is defined by financial and economic access. Now I'm experiencing higher education in the UK, and in the same way being a Black woman here reflects the same traumas that I suffered growing up. When I was experiencing that in Zimbabwe, there was no understanding of what racial psychological violence looks like for young people in the school system. It's interesting to see how that's a similar reality for racialised young people studying in the UK today.

I'm wary of the narrative that immigrants are 'good' only if they 'contribute positively' or they benefit the citizens of their host country in some way. That just means expecting them to legitimise, justify and defend their belonging where the default response of privileged groups is to discredit and invalidate their presence. I find the notion of borders violent and harmful. I think that all human beings should have free mobility. Every immigrant has a right to be here.

When I look at the resentment (at best) with which White nationalists regard immigrants, I think it comes from a culture of ignorance. Nathan Rutstein has described prejudice as 'an emotional commitment to ignorance', which this country has bred in its people through ignorance, using media and an education system that doesn't acknowledge the full historical and colonial context we exist in. The fact that people can defend Brexit – which is explicitly xenophobic – is shocking. The British empire wields its supposed superiority based on ideas of British exceptionalism, ethnocentrism, racism and eugenics. The intellectual and cultural superiority of the British empire is a fiction, and the notion that it was built without the labour of immigrants is dishonest.

This pompous yet failing country was used as a blueprint for what the rest of the world must look like. I walk around looking at the names of streets and buildings, the architecture of the city and how different suburbs are classified, but I first saw those names in my own country as the names of suburbs and streets in Harare. People are questioning the built environment around them: statues, monuments, road names. It's a triumphant moment for me to recognise that this country cannot function as the blueprint for the rest of the world. Embedded in its foundations are problematic ideals about power, national identity and economic development.

One of the biggest social upheavals is the resurgence of the Black Lives Matter movement. It has arisen again in the state-sanctioned murders of more Black lives. Of course, it is the peak of violence that triggers protests. Yes, it's a move in a positive direction that dissent is rising and is more widespread. It amplifies the conversation about whether or not this country can identify the colonial logic and racist legacy of an empire in decline. But I'm sceptical about our ability to address systemic ideals that are harmful *before* the harm has been inflicted.

To me, community mobilisation is integral to how societies should organise. The challenge is galvanising a community that supports these questions. It's been important for me to identify those people in my community here in the UK. There needs to be stronger solidarity between people and organisations working in these efforts, to develop radical strategies for community engagement or for creating spaces to educate people alternatively. That starts with employing anti-colonial, culturally diverse cohorts of staff in institutions and having them lead interventions at every social and institutional level. I am quite ambivalent about the future, but I'm given hope when people get up and decide to harness the power of community around them, coming together to produce something that tells a history that is more robust, more honest, a bit more human and factual.

PHOTOGRAPHER: ARPITA SHAH

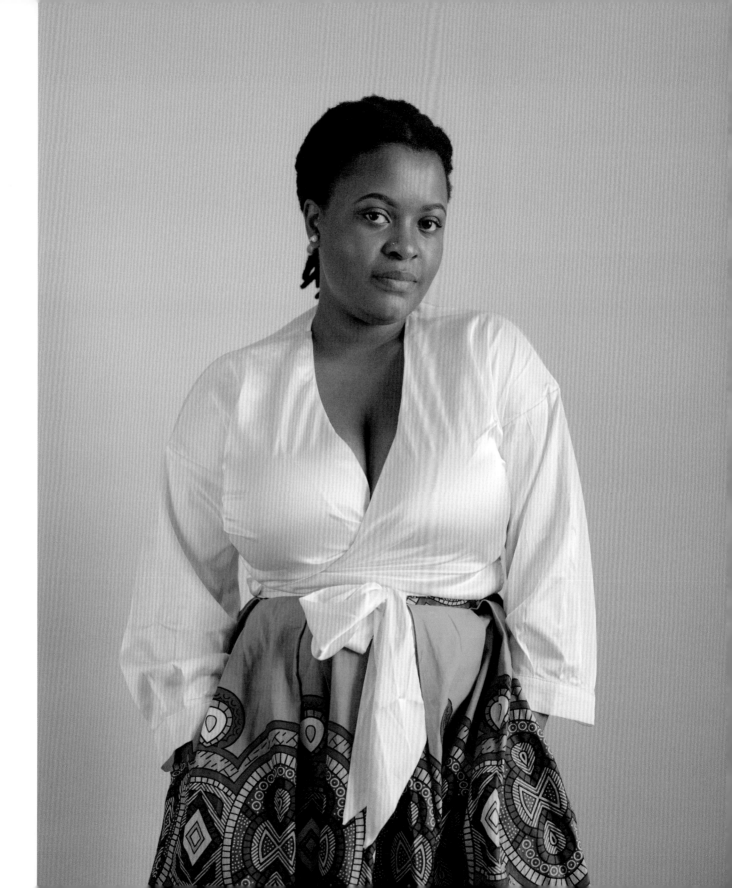

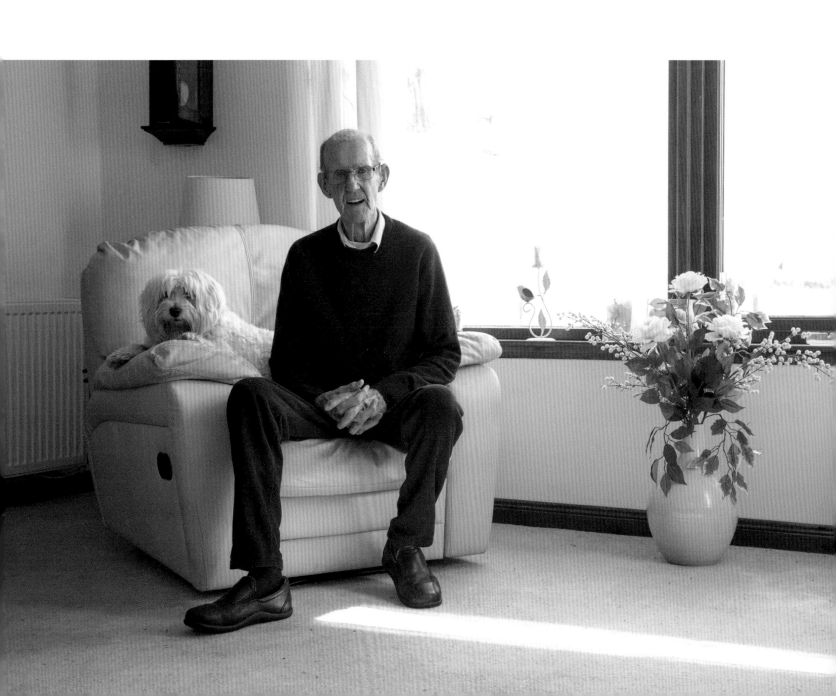

Donald Archibald Brown
Tiree

I don't like the Scottish flag for one reason: the Scottish National Party have taken it over as their flag.

I was born and brought up on Tiree. I left here when I was 16. I've been around the world for about 18 years but back nearly every year to Tiree – back home. It didn't matter where I was – whether I was in Australia, New Zealand or Japan – you always think of your home. You're more Scottish when you're away than you are when you're here. Whether it's here or on the mainland I've seen a lot of change.

I don't like the Scottish flag for one reason: the Scottish National Party have taken it over as their flag. Some of the flags have even got a bit in the middle with SNP on it, which really should be illegal. For someone like myself who's been all over the world, to become a nationalist would be very wrong. I was never nationalist or racist. I sailed. It didn't matter where you went, when you signed up it was never Scottish or English – it was British. On my naval card, I had that for 20-odd years: my nationality was British. You weren't supposed to talk about Scotland or England because the nationalists were always in the background, and they're actually worse now than they were then. They've got to keep it quiet, because it's like anything else: you get the gangs who go around the streets in southern Ireland and Northern Ireland. They're coming to Scotland to fight among themselves 'cause they can't get away with it in Ireland.

In my young days you were taught Gaelic till the minute you left primary school. There was very little English. It was Gaelic in the home all the time. In those days in Tiree there was no work, just paid crofts – small farms, under 100 acres, mostly arable land. There were about two or three big crofts, and if you were in with the factor you were all right. Of course, everything was done from Inveraray – the duke of Argyll. People were poor, but everybody was happy in those days because they were all the same.

There's very few Scottish people left in Scotland, really. The further you go up north – it's nearly all English or foreign. You go up to Aviemore – we usually do the coach tours right up to Aberdeen – and you go, 'Where's all the Scottish people?' They're away to Australia or somewhere like that. It used to be Polish coming in to do the labour; now it's more profitable for them to go back home.

I wish Brexit didn't exist. It's bad. But they wanted a vote on it, they got a vote on it. So by rights they should have just gone for that, but then Labour turned around and went against it. It didn't matter what was going to happen – they're against it. Because they would never be in. If the Conservatives got Brexit cleared, Labour would never be back in business again.

I would rather the Britain that was. But that was never going to be anyway. We've got to modernise. We've got to move on for the young ones' sakes. But are the young ones any better off than they were in our time? You know a lot more about life; your education is better than it was then. Irrespective of what anybody says, education is a lot better because of computers and radios and mobile phones.

We've mostly got Scottish rule, but they can't afford it. The farmers are worse off now than ever because, environmentally, they're talking about getting rid of them – cows, cattle. To get rid of that – what's left for Scotland? You can't transfer from a farm to an industrial unit overnight. What have you got left? I think it would be cruel. Because you hear so much about it. Different things.

People are well off now, whether in Tiree or the other isles, compared to what they were then. They may moan and groan but they're reasonably well off. But Tiree will never become an industrial place. It's becoming a holiday home, a party island, which doesn't suit the likes of ourselves, the crofters and that.

PHOTOGRAPHER: GINA LUNDY

Raj Budoo
London

My view is that Brexit is a good sign. It is an opportunity for the UK to evolve more because the UK won't be bound by European laws.

I'm from Mauritius. I grew up on a tea field. My family had tea plantations and a banana field. At weekends I'd help my dad out with his banana plantations and with his vegetable fields. Growing up, we were never lonely because the yard we were living in was full of children, full of cousins. We come from a huge family.

I moved out of Mauritius to make my life better. There was lots of unemployment at that time. An opportunity to apply for nursing came along and I applied; it wasn't easy because my GCSE and A-level results were not great. My written English wasn't that great either, but I managed to get five interviews to come to the UK.

I had a friend who was living in Ealing and got feedback from him that I would feel among my own there. I came to live in Hillingdon and I feel at home here. Mauritians mainly are of Indian origin, and in Southall and Hayes we have lots of Indians. In Mauritius we speak Creole, but we watch Indian movies, we eat Indian food. Even though I'm from Mauritius, it is still my community. We have several temples in Southall. Everyone will celebrate Diwali – it's our main celebration. You will do pujas, which are prayers. You can live in London and get everything that you need.

In England, if you've got your qualifications, it's a land of opportunity. If you grab the opportunity, you will be far ahead, and this is the only place in the whole of Europe that gives you that. For us, our opportunity was nursing. We improved our life from nursing, whereas my cousins in Italy tell me that they won't take you in if your skin colour is different. My cousin in France – he's got A-levels as well, and he didn't have any opportunities in France.

Some people talk about Britain being prejudiced. Personally, I don't feel that. It has given me huge opportunities, compared to anywhere else. I'm not saying that pockets of people aren't racist; you will get that everywhere. Maybe there is some underlying prejudice here, but you only have to step outside of England, go and live in Italy or go and live in in France and try to apply for a job. Then you'll see the difference.

Being a foreigner, it does take us twice as long to move up the ladder, compared to other colleagues. It depends how ambitious you are. In a way, it's not that we don't meet the qualifications: it's that we can't articulate ourselves. It's the language barrier. Personally, I don't think it's 100 per cent to do with the panel having race or prejudice in mind. Interviews are all about scoring: if someone does better than you in the interview, they have been able to answer all the questions properly and have been scoring more marks. If you score better than others, then you will get the job.

My view is that Brexit is a good sign. It is an opportunity for the UK to evolve more because the UK won't be bound by European laws. England gave me the opportunity to come here, to grow, to evolve myself. I believe everyone in the world should have the same opportunities to come to the UK, not only Europeans. But it is a small island – it can only accommodate so many people. For my children's benefit, they will probably have more opportunities in terms of jobs if the borders are still open. That's not racist; it's an economic view. When I first came in 30 years ago, we were very welcomed. But now, because of the open border, White British people have lost that tolerance. That's where Brexit is coming from.

PHOTOGRAPHER: AMARA ENO

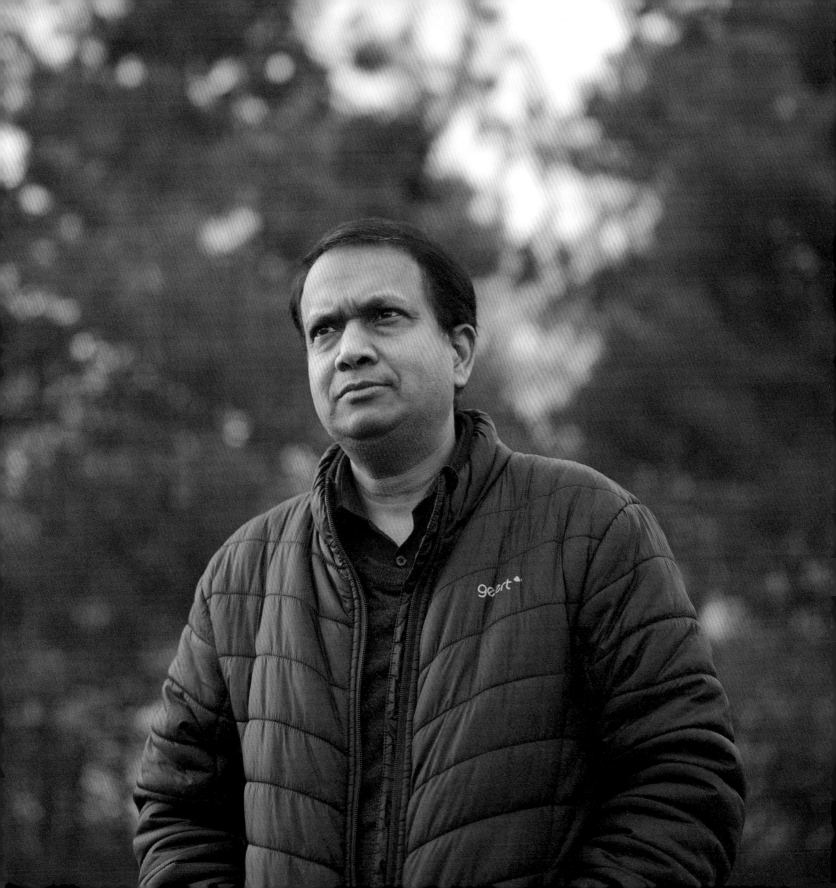

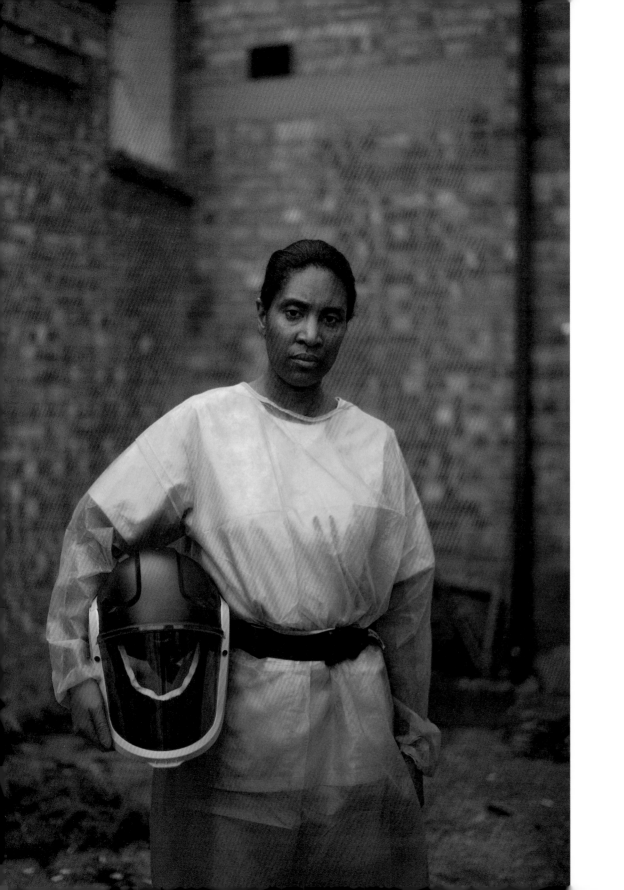

Diana Yates
London

The reason we are hearing more that 'Black lives matter' is because a lot of the time Black lives haven't mattered.

When I was growing up, I didn't know anything about Black history. All I was taught at school was Henry VIII, the Tudors – that sort of thing. Everything that was British history. We weren't taught that there were Black people fighting on the British side during the two world wars. I think it's really good that they are now starting to talk about it, and there are TV programmes on it. I can actually teach my children and explain things to them.

A lot of Black history in Britain is hidden. Recently, I read an article about how some of our museums were built through slavery. I didn't know that. I've got a few friends who are teachers, and they say the way they teach in primary school, they're not really changing the syllabus to include things like this. They have to fight to add bits and bobs to it to help people understand. There's only one way of teaching at the moment and that's the same way as what I was brought up with.

I grew up in Deptford, and there was a mix of different ethnic groups, different cultures. At my primary school we had Somalian, we had Chinese and we had Indian, Asian. I would say that I'm Black British. I was born here and all I know is England. The only things I know about Ghana are from my parents and what they taught me about the culture there. If I was to go to Ghana, they would call me an English person because I don't know the way they do things. It would just be like a White person – an English White person – going there.

The first time I experienced racism, I was about ten. I went to my cousin's house in Woolwich and there were groups of kids, White kids, older than us. I always used to have a fear that certain groups would do something to us and there were certain areas we wouldn't go to. One time we were just playing, hanging around. I was riding on a bike and my cousin was on his skateboard and there was this group of boys, all of them White. We were worried about how they were going to react to us. We went past quickly, and one of them said, 'You Black bastards.' I was terrified and so was my cousin.

That was one of the first experiences I remember. After that we decided not to play around that area. We didn't want to face anything like that again. From then on I was always careful. I did experience more racist abuse, but I just brushed it off and forgot about it. Because I was quite light skinned, I think I received less abuse. If I had darker skin and wore my hair in a more ethnic style, I expect I would have seen or heard more.

I was quite young when Stephen Lawrence was murdered in Eltham. I remember my parents talking about it and just thinking how sad it was that no one was there to help him. There were houses and houses full of people on that street. How come no one helped him or tried to save him? I wouldn't have gone to Eltham at that time. I would always steer towards Lewisham, New Cross, Peckham, Camberwell. Those were the areas that we went to because we would see more familiar faces, Black faces and people that we would be able to get along with.

The reason we are hearing more that 'Black lives matter' is because a lot of the time Black lives haven't mattered. We're not saying they're the only lives that matter, we're just saying that we're here and we want you to understand that we're not just trash on the floor. We are people as well. We are part of the human race. We should all be treated well, no matter what our race. We are saying that Black being killed as a result of being Black is simply not acceptable.

PHOTOGRAPH: FARAZ POURREZA-JORSHARI

Ron Hitchins
London

To me it doesn't matter what they do about Brexit, because all I'm going to do is abide by the law. But I look at it that there are people that are stepping on us.

According to what I've been told, my mother's family were Russian, but they had to go to Lithuania to get to England. So they said they were Lithuanian. They lived in Whitechapel, like a lot of Chinese people did back then. My mother went to Chinatown and she had me when she was young. She must have been about 15 when she had me. I didn't know my father. He's supposed to have been in the Chinese mafia. He was doing all the drugs and running opium dens, so he got deported. I never thought about trying to find him. All I know is I'm the only child.

I've got a photograph of when we were all the Chinese in Limehouse. The coaches used to come down to Limehouse to see Chinatown, Chinese people. And when they used to get in these coaches, called charabancs, to go back to the Midlands or wherever, all of us children would gather round and they used to throw us money out the window. I remember little restaurants there where my mother used to work. She was also a prostitute. I'm not against that, because she did it to keep alive. My mother was a partygoer. I was taken away from home when I was nine years old – so that was 1935 – for what they called 'care and protection'. Over the years she did come to visit me and brought presents.

I was ill-treated in different ways. I was ever so small. You got a good hiding for nothing back then. I got shifted from one place to another place. I got picked on for being Chinese. When I was 12 I stabbed someone with a knife – he was the school bully. I didn't like fighting and I used to box, but I hated it. I realised that walking away is the best thing.

The doctor came here one day, looked around and said, 'Oh, you must have travelled the world.' And I said, 'No, the world's been here.' I've had African people here, Canadians and Cubans when they came to England. I've been a professional flamenco dancer and the Gypsies accepted me, which is very difficult. But the greatest thing is, when all the people come to this country, they come to this house.

I don't vote because the politicians just fight each other. All they're worried about is: 'I want this job.' Why would you want to be an MP? I just don't know. You're on beck and call. You get blamed for everything. What are they doing today? They're not trying to help the country. They're actually fighting these others to get the job.

To me it doesn't matter what they do about Brexit, because all I'm going to do is abide by the law. But I look at it that there are people that are stepping on us. I mean, during the war we were the first people to help another country. But they forget. I've been talking to people that are Polish and I said they've forgotten that we've done this. I speak my mind. But if someone turns round and wants to argue with me, I'd listen to them. Keep quiet. 'Cause the less you say and the more you listen, the more you learn about people.

I've always been the one that's stuck up for the underdog. I've always been in trouble, fights, even when I was in the army. I've been sacked a few times. If something's been unfair, I'm the first one to help someone else. I don't do it on purpose. It's just natural. I've been in trouble, but I've always got out of it, I don't know how. I've always been a rebel. Always been different.

PHOTOGRAPHER: JENNY LEWIS

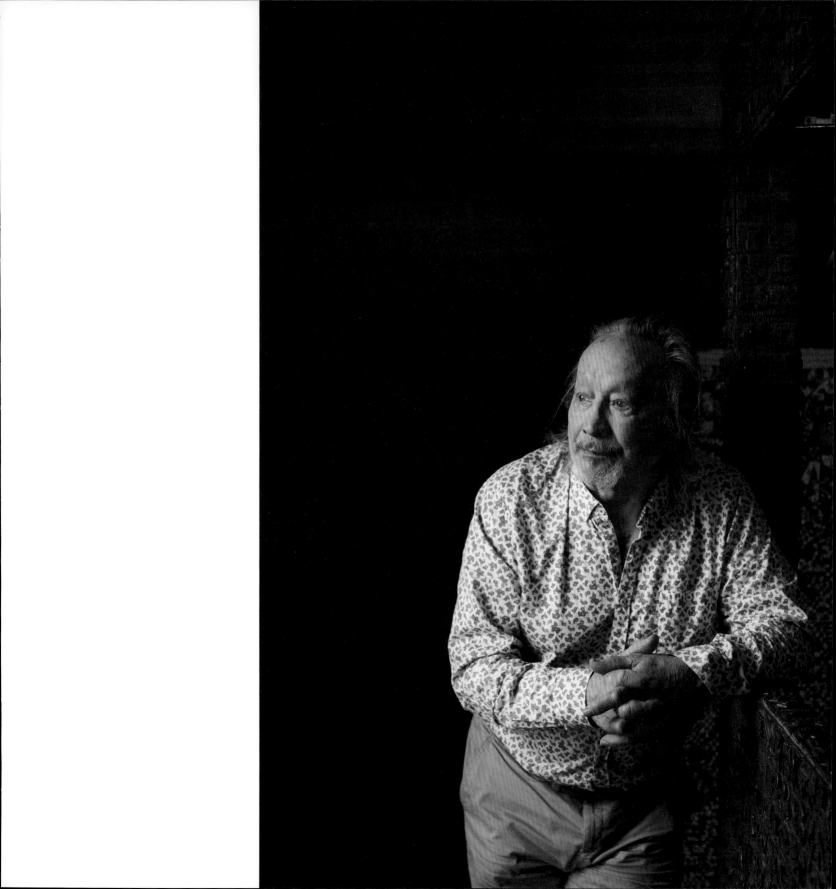

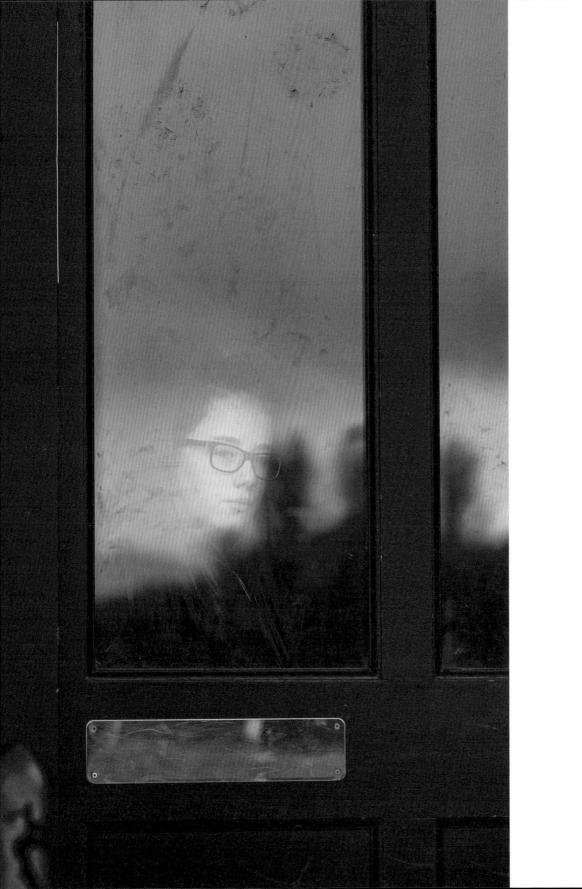

Brooke McMillan
Glasgow

I think immigrants should be allowed to come here. For all we know, they're getting hurt and abused in the countries that they're in right now, and they're maybe trying to get a fresh start.

I just got out of self-isolating and let's just say it wasn't the best. Obviously, you were allowed to go for walks and all that and you could see family, but I'm a kid that likes to hug my family a lot, and when we were in lockdown you had to stay two metres away. It's impacted me a lot because every time I saw them, I got emotional when I couldn't give them a hug. At the very start, when we got told that we had to go into lockdown, I was really emotional. I'm used to always seeing my family, and it was really hard at first.

I missed all my friends in school. I missed my prom. I missed one of my trips that I really wanted to go on that only P7s can go on, and I'm not going to get the chance to do that again. Also, at first, I thought I was going to go to a different high school than what I am now. It was really sad for me and all my friends because we thought we were never going to see each other again.

They're putting us back into another lockdown. I hope everything is okay for Christmas. In high school right now, fourth, fifth and sixth years all need to wear a mask in class. If I had to wear a mask in class, with my near-sightedness, it would be hard for me to learn as a mask makes your glasses foggy. It's also hard to concentrate with a mask on. I have an eye condition called nystagmus and can't see as far as everybody else. I've learned to deal with it, but without my glasses I just cannot see.

I think immigrants should be allowed to come here. For all we know, they're getting hurt and abused in the countries that they're in right now, and they're maybe trying to get a fresh start, maybe trying to learn more. I think they should be allowed into the country. I'm friends with a lot of people that are different colours and, honestly, I don't see anybody not being friendly with them, because as long as they're kind and helpful and they help everybody, everybody should be kind back and help them. It's not fair if they're being bullied just because of their race. I think if I saw somebody getting bullied 'cause of how they look and how they're dressing, I'd probably stick up for them, even if it was my friend bullying them. I'd stick up for the person getting bullied, 'cause it's not fair.

I've grown up in Scotland and I think my ginger hair is a part of being Scottish. I think we should get independence because in England they've got more people than us and their vote will count more than our vote will. It's not fair on us. We can have a better vote than them because we can vote for somebody completely different and they might be better, and then in England they're voting for somebody that might be rubbish. It's not fair on our country so I think we should be independent.

Krishnarine Lalla
Finsbury Park

I think that the people who voted to leave the EU are delusional if they think they are getting their country back ... No country is an island. It's all interlinked.

I'm ethnically Indian, nationally Trinidadian but now British. My grandparents came from India as indentured labourers to replace the African slaves when slavery was abolished. Indentured labour is another form of slavery. It still exists today.

I obtained my Cambridge Higher School Certificate, which is equivalent to an A-level, and later became an assistant master at Presentation College in San Fernando. To get our degrees we had to leave Trinidad and go to Canada, the UK, the USA or, if you were extremely lucky to get a scholarship, to India. To go to Canada you needed visas and a financial statement of support, same as the USA. It was easier coming to the UK because, being a British empire colony, all we needed was a British passport. I left Trinidad in 1960 with my wife and baby daughter on a ship, the *Marques de Comillas*, and landed at Southampton in dense fog.

Racism was very apparent when you were trying to find accommodation. You looked through the classified ads and you would find very suitable accommodation at the rent you wanted. But as soon as you appeared at the door you were told, 'Sorry, it's gone', and then you'd see other people going to the door and being shown inside to view the place.

Woodstock Road was the first accommodation we had in London that was bigger than one room. We now had a son and a flat, which had two rooms and a kitchen with a shared bathroom and toilet facilities. It was the first time we had our own door where, when we got in and closed it, we had nobody else there. Woodstock Road was also very close to the Tube station, transport and a fantastic green area called Finsbury Park. We spent seven years in Woodstock Road and we added two daughters to our family. We have good memories.

Woodstock Road is now gentrified. It's very clean. Properties are all done up. Where we lived has been upgraded significantly. In 1965 we attempted to buy the property from its owner. The asking price was about £3,500. Now I think it's worth closer to a million. When we were there, there were some West Indians and a large Irish population with a Catholic church and primary school. The current people are much younger and they look like a mixture of eastern Europeans, some north Africans and some from south-east Asia.

I think us immigrants have contributed a great deal to this country – socially, financially and especially in the health service. When we came, we took jobs that nobody else wanted to do. We had a lot of people coming from the West Indies specifically to train as nurses, starting on the bottom rung to get their qualifications. Nowadays, the NHS are getting people who come in as fully trained nurses.

I joined the Laboratory of the Government Chemist as a scientific assistant on 19 December 1960. I stayed with the lab until I retired as a senior scientific officer in 1994. I worked with a lot of British-born people. I started feeling British after eight or nine years, and integrated with the people at the lab. In the 1970s I was working in the foods division, when I was asked to go and work in the Ministry of Defence as an assistant to the superintendent chemist. The lab had a few personnel seconded to overseas laboratories as armed services food chemists. I was after one of those jobs, and I realised that it would be better to get a British passport so I could seamlessly move around. I did three tours, working in Cyprus and in Hong Kong twice.

Having worked with the European Union in foods, I understand quite a lot of the rules and why they are necessary. I think that the people who voted to leave the EU are delusional if they think they are getting their country back, because the world runs on agreements and nobody is independent. No country is an island. It's all interlinked. You may think you're getting a better arrangement, but you're better off in a big package rather than trying to throw your weight about on a small rock.

PHOTOGRAPHER: CHRISTINE LALLA

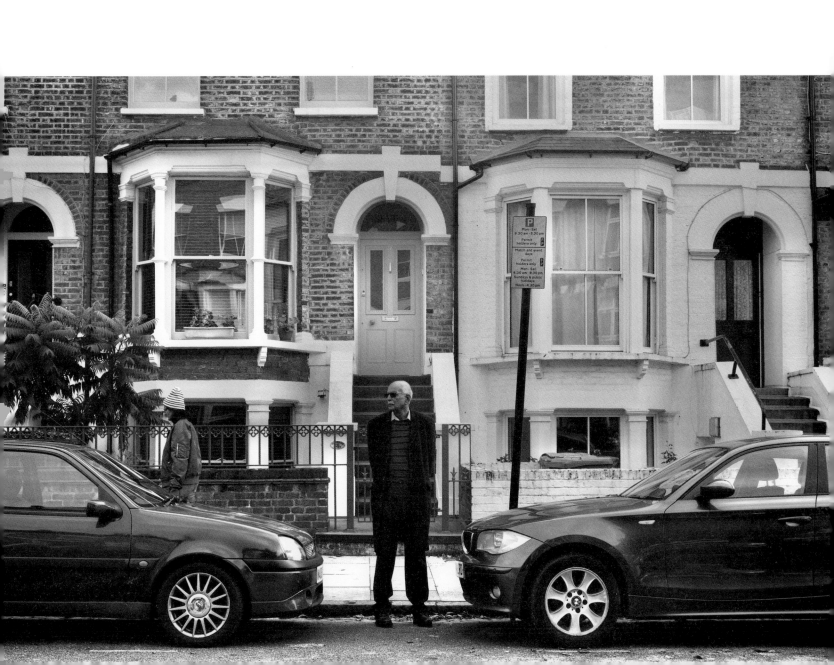

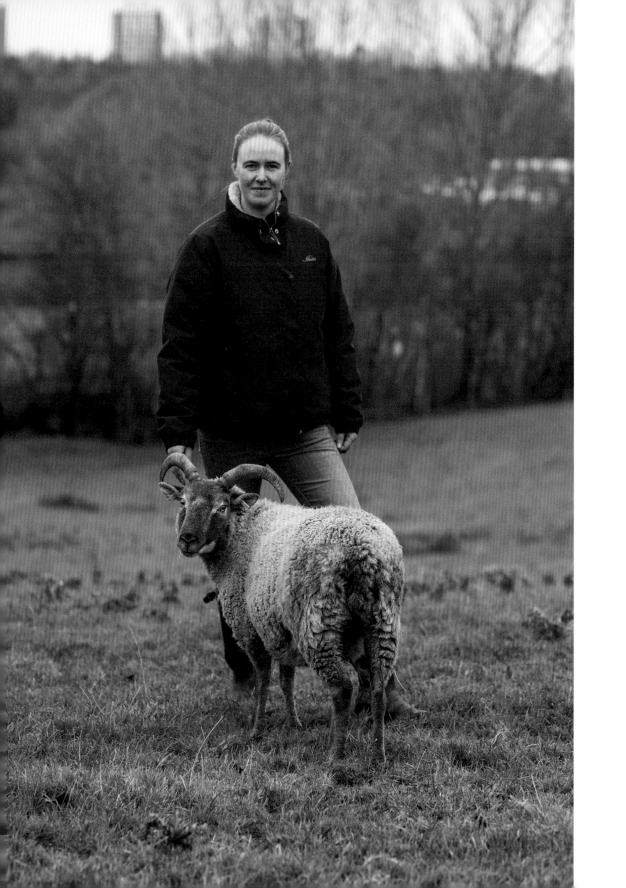

Hannah Davis
Gateshead

I voted to remain in the European Union and, given my chance again, I would vote to remain again and again … Brexit has just caused us to bleed money.

I live in Heaton, which is about a six-mile bike ride from Bill Quay Farm and a couple of miles from Newcastle centre. I started working at Bill Quay Community Farm in Gateshead in 2014, and I've since become a trustee of the charity association that manages the livestock, after the site got taken over. The local community feel passionately about the farm; it really pulls you in and makes you feel emotionally and physically connected to the place, the animals and the people.

When you're a queer person in agriculture, you don't know how people are going to react. You know that, at least historically, it's not been an inclusive space. I feel wary coming out. I don't unless I have to. If I meet people and they see I've got a wedding ring on, they may ask, 'What does your husband think about this?' I often brush it off and don't necessarily feel the need to connect. I'm definitely trying to be more explicit about being who I am, but it's still a scary thing to come out. You still hear and see homophobia, queerphobia and transphobia in everyday life.

I'm White and British, and Newcastle and Gateshead are historically very White areas. I think that is definitely a problem. With a colonial and imperialistic past there hasn't been land access for people of colour, which is terrible. At farm events there is some diversity. Additionally Gateshead has one of the biggest Jewish communities in the UK, so we get a lot of people from the local Jewish community coming and spending time at the farm. Gateshead is such a White area and some people's opinions have remained racist. People shouldn't feel that their access to the outdoors is limited because of their race; as White people we need to work to change, develop and diversify.

Today there is slightly more conversation around issues of diversity, but some people are still shocked that women are farmers. On social media I see people of colour who are fighting for land access and their right to access outdoor spaces. It doesn't seem to be changing at the moment, but I am encouraged by the activism that is happening online and I hope that that leads to real change on the ground.

I voted to remain in the European Union and, given my chance again, I would vote to remain again and again. The UK has been well supported by the European Union. A lot of funding that we get for research, land management and land use is from the EU. Brexit has just caused us to bleed money. For charity farms like Bill Quay Farm, or charities in general, funding was already pretty low thanks to austerity and the Conservative government. Draining European funding could limit people's access to the outside, access to animals, and create problems for people's mental health and livelihoods.

The idea that the British public will take on the jobs that used to be filled by European workers is outrageous and assumes that any person without a job would want to go and pick berries. It's classist and ableist, and to me what's most problematic is the dehumanisation. It's the thought that you can just buy and sell people, uprooting or leaving their families and expecting them to live in often poor housing conditions. It's the idea that, if you want to work, this is what is available, without actually thinking of the humans that you're affecting with your policies and practice. People in charge need to think more about the people on the ground doing the work.

As a charity that closed its doors before coronavirus, we were fortunate in that we don't have any staff, so we haven't had to furlough anyone or make anyone redundant. But it means that there have been less people on site to keep an eye on things. During the summer when kids weren't at school, or when we were in lockdown, we had more vandalism. And we haven't had donations, so we haven't really had the money to fix some of our problems as a result.

In the next ten years I'd like to see more diversity, more land access, more people being able to get into agriculture without feeling stigmatised or victimised or like they shouldn't be in the area they're in. I'm not necessarily sure how that's going to develop or how to make land more accessible, but I think inherited wealth and land could be looked at differently.

PHOTOGRAPHER: JOANNE COATES

Abba Bako
London

I think there is definitely a lot of work to be done to harmonise all of the individuals that are a part of the Black Lives Matter movement.

I would describe my ethnicity as Black British or Black African. While it doesn't really have that much of an impact as to how I see myself directly, I'm aware of the cultural expectations and challenges that those from Black ethnic backgrounds face. Despite these challenges, I'm determined not to allow my ethnicity to dictate the legacy I leave on earth. I believe that, to succeed in any area in life, the onus is on me to be able to work with the cards I've been dealt to maximise every opportunity in life. I'm fortunate and blessed enough to be where I am in life today, so I try and make the most of it.

I am a Black man. However, that's not the core of my personality or my character. While it's what I'm identified as and I am very proud to be Black, I will not allow that narrative to govern my actions and to be the sole or primary lens through which I see the world. First and foremost, I'm a Christian before anything else, which means that the principles and truth of the word of God, which is revealed through the Bible, are what I live by. These biblical truths do not alienate me from the social, economic and political constructs we see in the world, but empower me to add value to whatever I find myself doing.

I think there is definitely a lot of work to be done to harmonise all of the individuals that are a part of the Black Lives Matter movement. There seem to be some disparities in the aims and goals of proponents of the movement. While I believe that most of the individuals who are part of BLM have some great intentions and truly want to change a number of racial issues, the movement is also saturated with a number of people who support the campaign for personal and selfish gain. The spearheads of BLM need a lot more strategy and unity within their camp to tackle real racial issues within societies around the world. While I respect the movement and acknowledge its need, I'm not a staunch supporter.

There is still a lot of work to be done for Britain to atone for the grievous acts it committed in the past. Looking at history, you can see how Britain forced its way into a number of nations around the world. The UK still has a lot of work to do to be accountable for its actions, and while you can't really pay back the number of lives lost and everything that happened, you can still make amends and take steps to right some of the wrongs. The UK as a nation has a number of artefacts that were stolen from other nations. These need to be given back in order to take some steps towards taking responsibility for past actions.

In London, where I live, it's clear to see how diverse the city is. Although one could argue that it's still not enough, the general consensus is that it's going in the right direction. Within London there's such a cultural community, and that obviously makes the UK as a whole look more diverse and inclusive of all cultures and backgrounds. However, if you look at places like Plymouth, for example, where I went to university, it's quite conservative. It's still very much, for the most part, a 'keep to ourselves' type of mentality. While there is some diversity brought by the university students, when you visit places like Plymouth you realise that diversity and inclusion are not as popular outside the big cities. There is still a lot of work to be done for the UK to be more diverse.

PHOTOGRAPHER: ADEOLA ADEKO

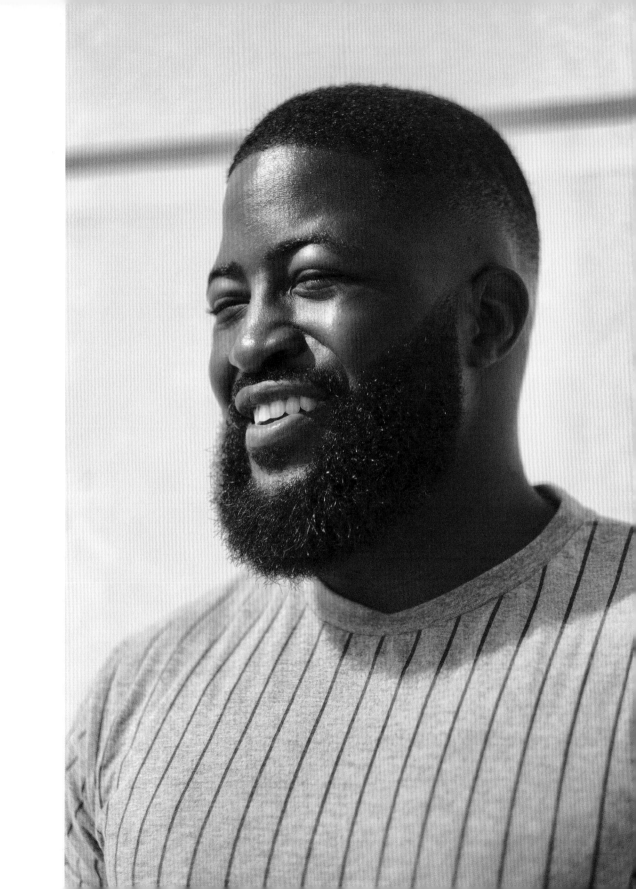

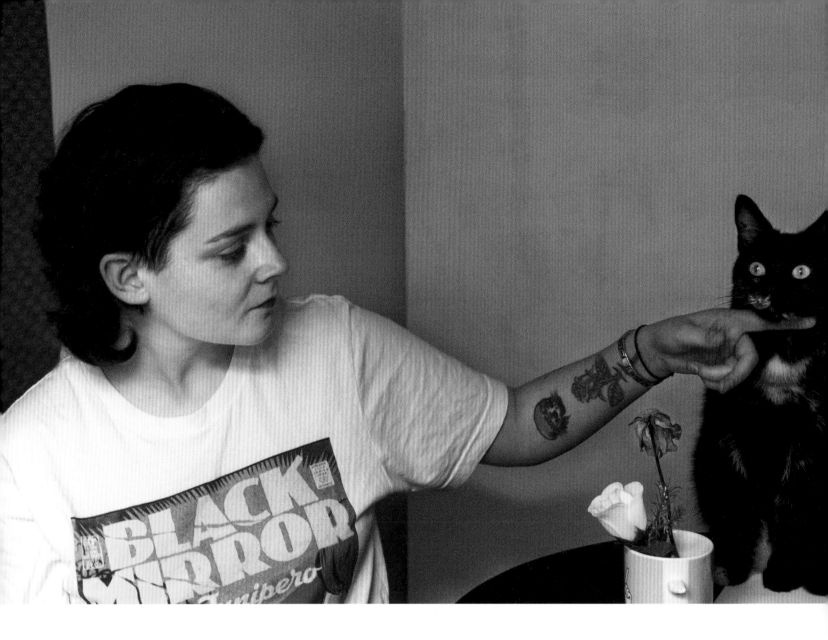

Susie Donaghy
Belfast

People joke that, as the millennial generation, all we do is joke about everything, but it's to deflect from the fact that life is actually terrifying.

I grew up in Foreglen, a village about 20 minutes outside Derry City. I moved into Derry City for university and stayed there until I was 25. I've always considered myself from Derry. I feel that community, though Belfast is a lot bigger and I have family there. I'm torn between the two.

I was born in 1993. There was a ceasefire, but the Troubles didn't end until 2005, and there was a British soldier at every gate. I remember the soldier at my gate. He was only 18 and I used to play snakes and ladders with him. He let me look through his sniper rifle's sight. I grew up with it, so it just felt really normal. I was terrified of helicopters, though. I don't know why. There's still helicopters and there's a Land Rover that goes round the area and patrols all day and night.

We have quite a beautiful little choice here, where we are dual citizens. We can decide if we're Irish, British or Northern Irish. Personally, I'm Irish, but it's nothing to do with hating a certain group of people or loving a certain group of people. It's more I'm on that island of Ireland and I'm Irish. But there are people who are born here that are British. They feel British. It's mostly the Protestant/Catholic divide, but there's people who don't care any more.

It's the same with Derry/Londonderry. I don't care if people say 'Londonderry'. If people try and correct me if I say, 'I'm from Derry', I'm like, 'No, I understand how to speak. I'm fine with just calling it Derry. It's easier, shorter.' But if people call it 'Londonderry' I'm not going to pretend I don't know what they're talking about. It's, like, what's in a name? In Northern Ireland, apparently everything.

I don't think it's affected me, really. It's more legal things, like there's certain music competitions in the South I've entered and they've realised I was from Northern Ireland, so I wasn't allowed to enter because there's some small legality in their clauses. And then there's laws in the UK that aren't applied to us, and laws in the South that aren't applied to us, and we're stuck in the middle. I think that's more a problem than how I identify.

I'm always terrified when there's a big change politically, because here it's like a powder keg, especially when there's still these cultural events that make tensions rise even more. If they were just cultural events, I would embrace them. I'd love to go to the 12 July family fun day, and one of the bonfires and the parade. It looks like fun, but not when they're burning a flag that says 'Kill all Taigs'. I don't feel safe. I have friends who are Protestants and they don't care. They're not going to hurt me. But I don't know what it's going to be like on a night like that, where there's tensions and everyone's riled up and there's a giant fire.

There was a riot in New Lodge recently and there was a big joke, because two kids were protesting on top of the bonfire and they tried to get a Deliveroo. And the police couldn't get the kids off the bonfire, so they wouldn't let them get their Deliveroo. People joke that, as the millennial generation, all we do is joke about everything, but it's to deflect from the fact that life is actually terrifying. If something happened outside this window right now, if somebody murdered someone and I saw who did it, I would be terrified that I would get killed if I reported that person to the police. We joke about it, but it's actually real.

There's no more British soldiers. The Royal Ulster Constabulary is now the Police Service of Northern Ireland. We almost have equal marriage. Westminster passed it. They basically gave us an ultimatum: if people don't take their seats in Stormont, then equal marriage will be passed on 28 October. Everybody's joking the Democratic Unionist Party won't sit 'cause Sinn Fein want to pass the Irish Language Act. So people are joking that the DUP now has to decide who they hate more: the gays or the Taigs.

PHOTOGRAPHER: KATE NOLAN

Ron Lyne
The Lizard Peninsula

I don't think any good will come from Cornwall – or even Scotland – being separated. We all need to be solving problems together and not making our own rules.

I'm not English. I wouldn't want to be English. Nothing against the English – each to their own. I assume that I am a Celt because my family come from Wales. But at the end of the day I'm Cornish and British. I think most people should be proud to be British. The Lyne family came from Caerphilly in Wales to the Lizard village in 1511. Our family have been farmers in the past, although we came here as tax collectors. The area where I live is very rural – we are out on a limb. Every decade has been changing faster and faster. When I was a teenager in the 1970s, it was farming, fishing and serpentine, a little bit of tourism. And now tourism has taken over all of that. The population here in the Lizard has just escalated; every decade it seems to double. There's a lot of wealthy people coming to the village that are buying second homes. Five years ago, we didn't have any second homes. People used to come to the village, have a cup of tea, just look at the shops and go. But I think people are now buying second homes in this remote place, renting them out and making money.

Growing up in the Lizard, it's been very safe, even for my children now. It's a very tight community. You know everybody in the village. But there are also a lot of challenges. You'll find you have to try a bit harder for opportunities round here. You'll notice more of the seasons. When you live in a town or a city, you don't really notice the change in seasons. The winter is more of a challenge, 'cause we're quite remote. Transport is a big issue.

I think we've lost that religion kind of thing, which is a shame. I think that's our own fault for not keeping up with a whole range of Christian religions. I don't think they've kept up with this day and age really. I'm not religious, but I encourage my children to learn about different religions and cultures and have that opportunity to decide for themselves. Now you have the opportunity to learn every religion and choose which one you want.

We've had a lot of European grants, probably sourced by the local council, not by politicians. Politicians don't really recognise Cornwall.

I loathe them. They're all private school people, I don't think they're working-class people. They're not looking after the fishing and the farming and all of that. They seem to think everything revolves around them and their pockets. They were totally wrong with lockdown. If lockdown in Cornwall was to close the border and let Cornish people get on with their own lives, we would've managed better financially. Cornwall has to be part of Britain. We all need to live together, and the way things are moving is that we're all nationalities and people moving around. I don't think any good will come from Cornwall – or even Scotland – being separated. We all need to be solving problems together and not making our own rules.

Brexit is a bad thing, in my view. It's gonna cause a lot of problems. We need people to freely move all over here and Europe. Who's gonna do all the farming work? Because we're not gonna do it. Somehow people think they're beyond that. They may have wanted Brexit, but if they can't get the nationalities from Europe to do that, that means either the farmers are gonna struggle or have to pay double the wages to encourage British people to actually do it. People coming here to work, they've gotta get visas. It's all paperwork, more paperwork.

There are not many cultures down here. Living here has a bit of disadvantage with not knowing all the cultures of other people, as they kind of keep to the towns and cities, so down here we don't experience that. I don't know of any Black people living in the village. So I think we're missing out on that, really. If we lived in the city, we could be more knowledgeable of their culture.

Britain is divided, very much so. The government are always supporting the rich, and I think that's because they're afraid of the rich. They've always hammered the lower class. I reckon it's divided between the rich and the lower and middle class. If you get some working-class people in there, things could change.

PHOTOGRAPHER: MAISIE MARSHALL

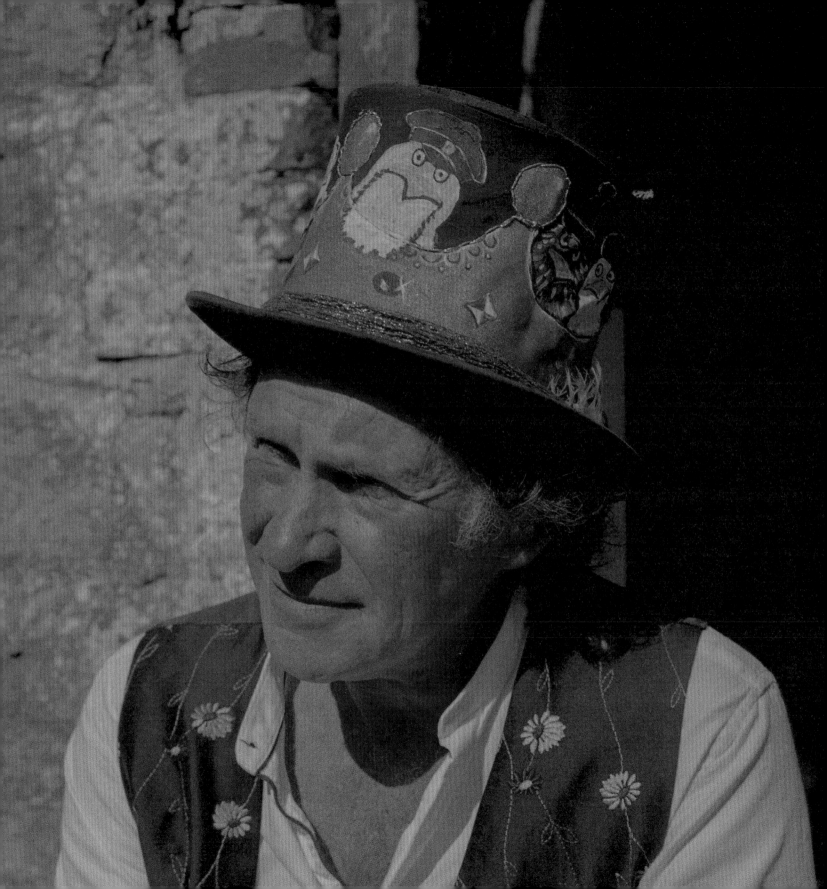

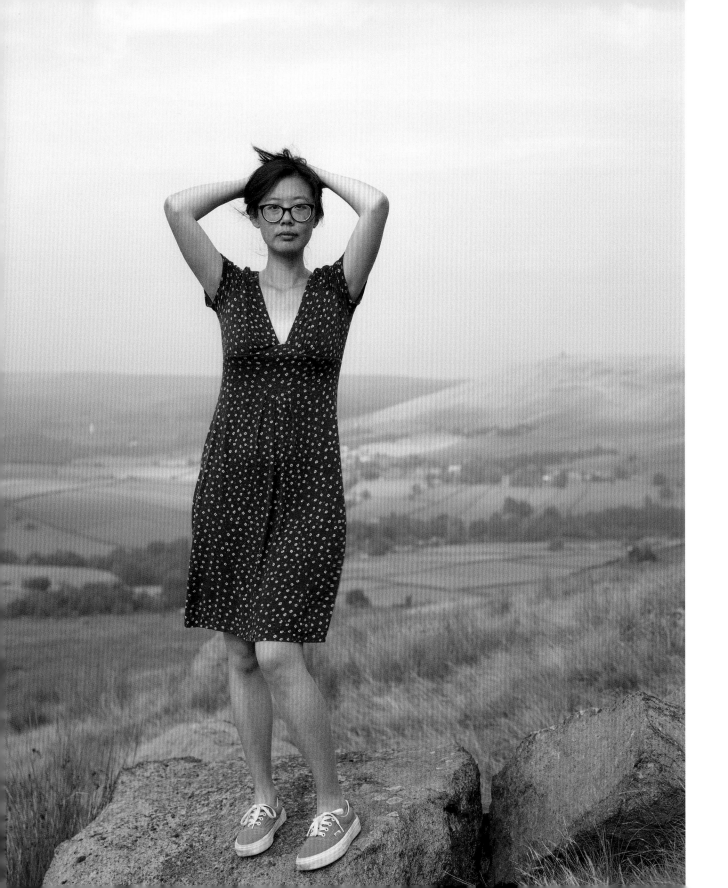

Christine Zhou
Todmodern

The first time I came to the UK in 2016 I was interrogated at immigration … It was the beginning of the Brexit thing, which I was oblivious to.

When people ask me where I'm from, I usually think, 'What do they really want to know?' I normally give a standard reply: 'I'm from Canada.' I left Beijing around 1989, aged six, to go to Canada. I remember looking out the window on the plane at night and thought I was flying through space to another planet. I grew up in Toronto and lived there much longer than any other place I've been. My education was there, and my Chinese culture and heritage is kind of from all the Asian immigrants there. As a Chinese Canadian growing up in Toronto and Montreal, I had always thought that other western countries were similar to us, because these two cities are such a melting pot of diversity. We pride ourselves in our anti-prejudice education.

The first time I came to the UK in 2016 I was interrogated at immigration. I wasn't paying much attention to what was going on in the UK. It was the beginning of the Brexit thing, which I was oblivious to. I arrived and then right away my happy feeling got shut down at immigration. The guy started interrogating me, asking invasive questions that weren't very friendly, like 'How much money do you have?' and 'What are you doing here?' He didn't ask questions in a way that felt comfortable to me. It was basically, 'Oh, you're a refugee coming here, you're not just here on vacation.'

I had never experienced this kind of prejudice from any other western countries, and I've travelled to many places. I was made to feel guilty for wanting to come to this country as a Chinese Canadian – it wasn't a good first impression. I came back for a visit with my husband and we both got the same treatment. We both got deemed 'poor and unworthy of respect' because I am a musician and my husband is an artist. My general feeling was, 'Why are you guys treating us like we're doing something wrong for no reason?'

The third time was the worst. I was coming from Toronto and, as soon as I got into the line-up, I looked at the immigration officers: four Asians and one White woman. They looked like a special task force. The woman asking the questions was getting really upset with me. She interrogated me and made me answer the same questions three times. And then she wanted to see my bank account and how much money I had in there. She accused me of making her job difficult, and after I apologised a couple of times she eventually stamped my passport. But just going through that process was very scarring, actually traumatising. I was very upset for a while, 'cause it made me feel shitty for no reason.

The few times that I've encountered this type of prejudice at the airport was from Asian and non-White officials. The few times that I've encountered normal questioning, they looked like White British people. People have said that British racism is more subtle – I think that's the general stereotype of British racism. However, racism doesn't have a colour, anyone can be a racist. We all need to be anti-racist no matter what your skin colour is. What really matters is the colour of your heart.

I never thought of myself as an invasive plant, but as a human being exploring her home, planet Earth. We belong where the wind takes us: sometimes it's just where it is and sometimes it's miles away. For me my home has been Beijing because I was born there, Toronto because I grew up there, Montreal because I found myself there, Paris because my godmother lives there, Shanghai because they are my grandmother's people, and now Todmorden because I am reminded of my true self here.

They say home is where the heart lies. For me home is where the wind takes me and now it has taken me to Todmorden. It's not just where your heart lies but also a sense of belonging and contributing something meaningful to where you call home. And that takes time, kindness and courage. I don't feel I'm completely there yet, but I feel at ease living here in the moors and the hills. I have found love, kindness and courage in the people that live here and I'm slowly making lifelong friends.

PHOTOGRAPHER: YAN WANG PRESTON

Rabbi Herschel Gluck
Stoke Newington

I think there is an attitude that anti-Semitism is not right. It is being challenged by the state, by fair-minded people, and we need to build further on that.

My family home has been in Stoke Newington for basically my whole life. I was born in Westminster, but at the time my parents lived in Kyverdale Road. At the age of one and a half we moved into this street. My family home has been here for about 60 years. I've seen a lot of changes in the area and it's become more and more like an appendix to central London. There's been a tremendous overspill from Islington to such a degree that Stoke Newington has overtaken it as a place where media people and lawyers seem to want to live. It's an interesting development from being a place which was primarily working class and known for its dissenters: a lot of suffragettes, a lot of Jewish people, Black people of the Windrush generation and a lot of Muslim people who came down from the mill towns when the textile industry contracted. Many of these people have had a tremendous effect on British society and have contributed an enormous amount.

I'm a European Jew and my ancestors have lived in Europe for thousands of years. My father's parents came to the UK in the late 1930s from Austria, and were very appreciative of finding refuge on these shores. My father came over at the age of 15. At 18 he joined the Royal West Kents, and he saw active service in Italy during the Second World War. He was one of the British soldiers who liberated Bergen-Belsen, and worked with British intelligence in Berlin, where he helped to translate the archives of the Gestapo into English.

My mother came over with the Kindertransport at the age of ten, from Vienna, after her parents were murdered by the Nazis. My parents were very, very English. They had their childhood in Europe, but when they came here they very much appreciated Britain and what the country had done for them. So I grew up in a home where we were proud to be British. We felt gratitude and a sense that we have a special duty to contribute to British society while being proud, committed Jews.

Being a member of a minority is to a certain degree a double-edged sword. On the one hand, you're seen as an outsider, as not really British, even though I'm third generation. But on the other hand, being a member of a minority gives one a special perspective that those who are not might not notice. Being a Jewish person in the UK is a great blessing in my opinion because the UK is a very tolerant society, generally.

Britain today is much more dynamic than the Britain of my childhood. Coming out from the privation of the Second World War and the years following it, the country was still lacking confidence and that is why we had incidents like Enoch Powell's 'rivers of blood' speech. Today's challenges are very different from those that we faced when I was a child. We have much more choice, much more ability to be ourselves.

In the 1970s anti-Semitism was just part of the flora and fauna of society. No one would report an anti-Semitic incident because it was just part of life, like how the sun comes up in the morning and sets at night. But today I think there is an attitude that anti-Semitism is not right. It is being challenged by the state, by fair-minded people, and we need to build further on that, because there is still, sadly, a lot of anti-Semitism in society. Even though there have been tremendous strides forward, there is still room for further good to be done.

When we started the Muslim Jewish Forum [of Greater Manchester] in 2001, it helped change the way Jews and Muslims perceived one another. And this has not just had an effect in the UK – it has become an international phenomenon. Many people have been encouraged by our work and set up similar groups around the country and across the world, and it has been highly advantageous for both communities. We have helped many young people to feel that members of the other community are not enemies but allies.

Life is short. I think I'm five years old and I look at my passport and see I'm 61. We may pray to live to 120. That is still short. But, if we try to engage with one another in a constructive way, we all benefit.

PHOTOGRAPHER: ANDY AITCHISON

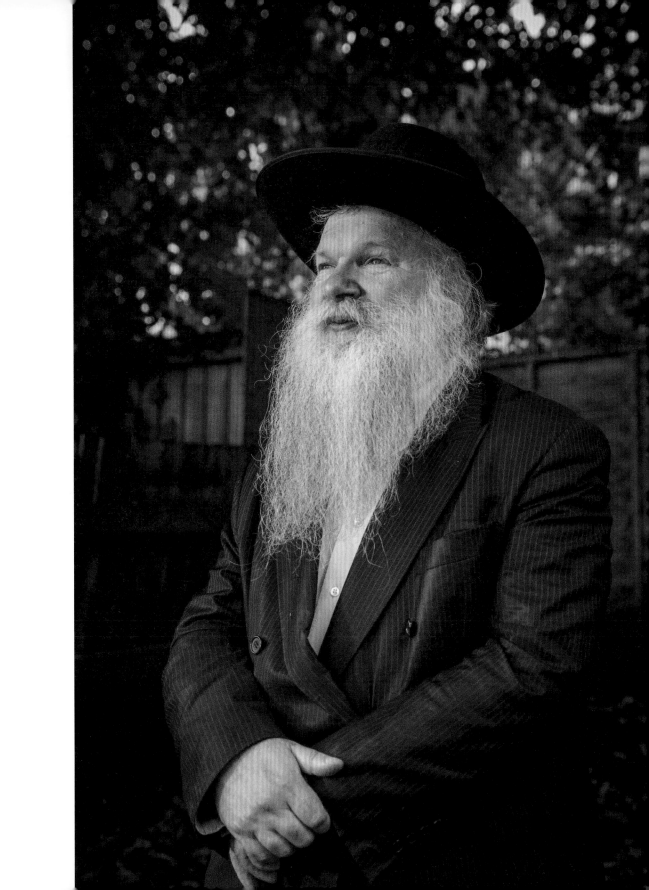

PHOTOGRAPHER: RHYS BAKER

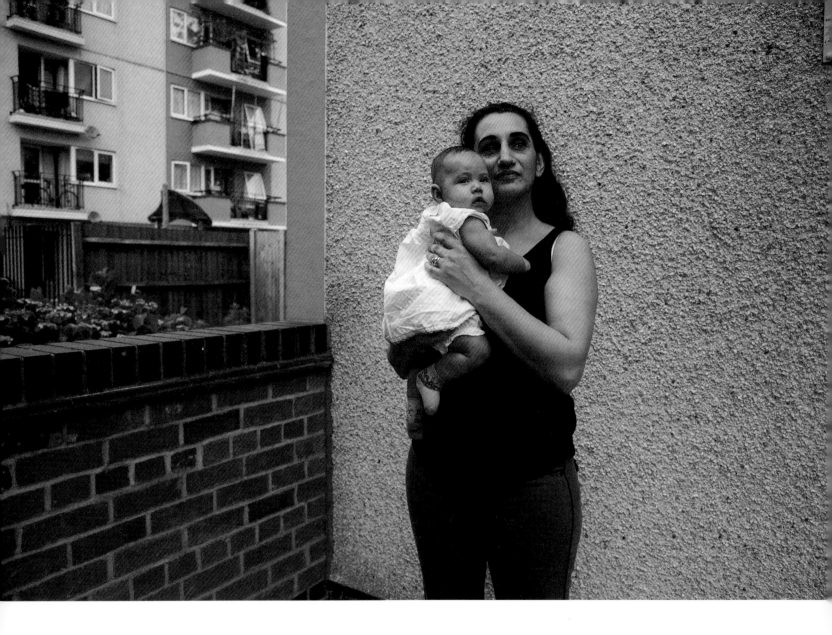

Tanya Costa
Tower Hamlets

When people know I'm a Gypsy, they treat me differently. If I'm talking with one of the housing officers, sometimes the guy will look at me and ask if I'm a Gypsy and start to laugh.

The area where I live is new for me. I moved seven months ago, and I don't like it. I don't know anybody around here and I already have problems with the neighbours. I used to live in Hackney, which I loved. It's where I know everybody. It's where I arrived to live, homeless, and I met lots of people there. Good, bad, but most of them are still my friends. Now Hackney has too many new buildings, too many coffee shops. I haven't been there for a little while, but I always find out we have another Costa Coffee, a new McDonald's. Lots of things change in Hackney and it's getting expensive.

I'm a Gypsy by birth, but I've never been considered a Gypsy woman, because I've always been with foster parents and care homes, so they consider me to be a normal White woman. When I was 16, I decided to leave my community because I didn't like the rules. You can't choose your husband, you can't smoke, you can't drink, you can't go to parties, you can't travel by yourself. You can do nothing, basically. I said to them, I'm not up for this. I want my freedom.

I was supposed to leave Portugal when I was 17, but my mum refused, so when I was 26 I came to England. When people know I'm a Gypsy, they treat me differently. If I'm talking with one of the housing officers, sometimes the guy will look at me and ask if I'm a Gypsy and start to laugh. And I don't like it, because I never tell anyone I'm a Gypsy. It's different if they know you are from another culture.

I've been through so much since I was a child. As a teenager, a single mum, I lost my kids, been homeless in different countries. At the moment I'm feeling OK, but at the same time I'm not. I'm still fighting with my demons and this country has been helping me a lot. I never want to experience those things again. Here, I have the opportunity to be someone I never was in Portugal. There, they don't care if you're crazy, if you have problems, if you've lost your kids. The UK has given me the opportunity to have my child with me. I've been on alcohol, I've been on drugs, I've been in lots of problems, and they still give me the chance to prove to them I'm going the right way.

When I first arrived you could go in the streets freely with no problems. I lived in Grantham in Lincolnshire, and I loved it – it felt nice. Even the police were nice. I once asked them for help, and they helped me. I never had problems with the neighbours. Then I moved to Bedford. It's good, but there are too many Portuguese people there, and when there are too many people from one place it creates problems. That's why I decided to come to London – freedom. I paid for my freedom, but I feel a big, big difference from 13 years ago.

I think immigration has had a very big impact on the country. Now you can see more criminals, more homeless people, more poor people. I worked here a long time in a very hard job. Most men don't do that kind of job, and today I'm in this situation where I can't work because of my accident. Most of the money that could benefit me goes to other people first. But I know there are people who've been working more years than me, and they receive basically nothing, while other people receive benefits, even though they've never worked.

I know a few people who are very racist, but people who are from other countries understand each other. The UK gave me the opportunity to have a new life, especially with my baby. I'm a different person, thinking differently. I want to explore the country more in the future. I want to raise my child in this country, in the right way, and teach her how to deal with people: not to be rude, not to be violent, but at the same time defend herself if someone does something wrong to her.

PHOTOGRAPHER: ROLAND RAMANAN

Adebola Alaba-Ige
Wolverhampton

I think immigration has a huge impact on the UK. The immigration system made everyone synchronise; there's this level of accommodation and the perspective in which people see things.

I was born in Nigeria into the tribe of the Yorubas, which is in the south-west. The Yoruba tribe is very divisive in the sense that there's really no support for each other. Within the family, there is this closeness, but in the extended family, there's this scepticism where they are always suspicious of each other. My dad never wanted us to mix with his brothers because of their extreme traditional views. When it comes to tradition we follow it to the letter. The way I talk to people, the way I relate to people, is very respectful and that's part of my Yoruba identity. We respect people but not inwardly: we respect people outwardly.

There's no society where you haven't got extremists in terms of views about foreigners and things like that. But the people I've found myself in contact with within the community, and the people I tend to relate with – I've found that the British character is excellent in terms of the way they accommodate other ethnicities.

I really love the character of the British. They want to share with you. I've got a neighbour who's always at my door asking how I feel. I was telling my wife this morning that there's a woman, I think she's from here, and every time she sees me, even though she doesn't know me, she greets me. That's what I've always found, even when I was in London. Every time you go into the store, they'll always say 'hi' to you no matter what you're doing. There's no sense of relegation, where you think you don't belong. I've never really seen or experienced that. I love it.

In Nigeria, you have the very rich and you have the middle class. The rich don't really reckon with the middle class and actually see them as part of the very poor class. So, because of this class difference, there is always the higher class, which is the class of the aristocrats. They are the ones that use their power, they are always the ones in charge, and they maltreat and relegate people from other classes.

I think immigration has a huge impact on the UK. The immigration system made everyone synchronise; there's this level of accommodation and the perspective in which people see things. Now you can see the variety. You can appreciate the variety of things. I think it's changed to be better in the way people mingle and relate to each other. A lot of people appreciate immigration – there's only very few that don't appreciate it. It has a positive impact. Some of the media misconstrue information and try to blame immigration for the decline in some things, so at the end of the day, people think, 'Oh, so they're the ones putting pressure on the benefits system.' I've never focused on that. It's just a very minor number of people that project the image in the wrong way.

My main reason for coming to the UK was to build value for myself so that, when I go back to Nigeria, at least I can do something. I can affect the system. But when I got here, I then had my children and things changed in the sense that I have a female child and I know what happens to female children in Nigeria, who have to undergo FGM, female genital mutilation. It's a traditional thing you have to do. There is nowhere to run to – you cannot escape. It is actually the aristocrats who use their power to support FGM. If you try to escape, people are not going to support you, even extended family members. They are not aristocrats but they are affiliated with all these laws, and if you don't follow them you are subjected to alienation and it can cost you your life.

PHOTOGRAPHER: KRIS ASKEY

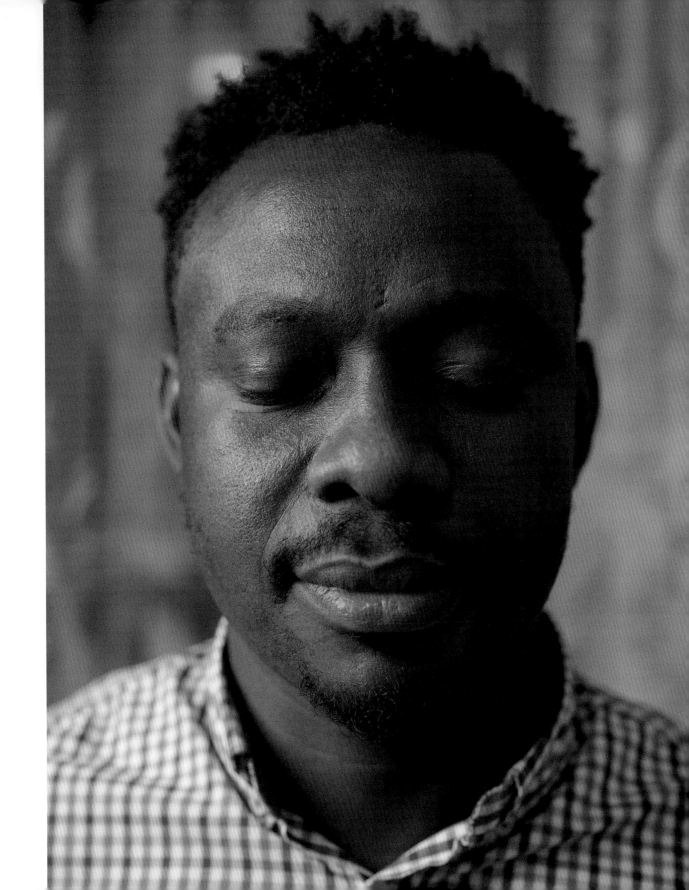

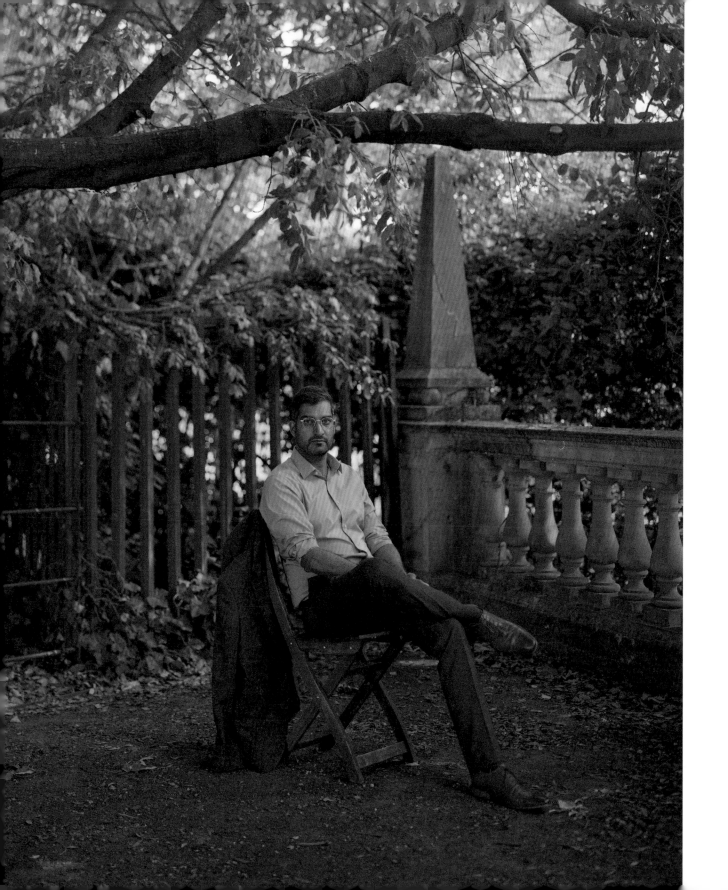

Gagan Bhatnagar
London

I am confident that the real saving grace of British society, regardless of which end of the spectrum they are on regarding Brexit or immigration, is their love for the NHS.

I was born in Sweden; my parents had emigrated there from India. I then moved to Belgium for two years, to India for five years and then back to Sweden from the ages of 13 to 18. Having finished high school, I came to England and I've been here for 17 years. If I had to tick a box on a UK government form, I would tick 'Asian/Other', because I'm not Asian British. I feel my identity is very distinct from Asian/British. In terms of my ethos, I'm very Scandinavian or European, but culturally I'm still a Hindu Indian.

I went to King's College London and studied there for seven years, gaining degrees in medicine and aerospace physiology. I'm fortunate to have been exposed to and integrated with many different races and cultures, and I think I'm better for it. London, which has been my base for the majority of my time, is a multicultural hotpot, which is something you don't get as much of in Sweden, and I love London for it. I've been exposed to a lot of cultures in my life and I think I'm probably more open and accepting than I might have been otherwise.

I now work in the National Health Service as a cancer specialist focusing on chemotherapy and radiotherapy. I am a huge supporter of the NHS because I think it represents the best of society. It also fits in very nicely with the Scandinavian spirit I've grown up with – health care for everyone. Free at the point of use. Your income, status or place in society doesn't matter. It's about what your need is, and that is a principle I hope England never loses. Sometimes I worry that it's going in the wrong direction.

I started feeling 'othered' around the run-up to Brexit, when my origins came to the forefront of the political discourse. I had felt like a Londoner, that I fitted in. Then all of a sudden this national discourse saying you are the 'other' changed that. The anti-immigrant rhetoric escalated very quickly. 'You are here on our want and you are here to provide a service.

If you don't provide a service, then get out.' That was odd to me as I'd never considered myself to be an 'other'. Whichever country I've lived in, I've integrated into society.

I feel like England has become less tolerant and I don't necessarily think it's of people like me. I'm a well-spoken, Indian-looking NHS doctor. I think it's about people who may not be as well spoken or don't have as respectable professions, but who nonetheless do very important jobs. For example, fruit pickers, whom we rely on heavily, were vilified. That loss of tolerance makes me very uneasy.

When I was younger, making decisions about where I would go to university, it was easy to choose England. It had this air of a multicultural hotpot where everybody gets along. It was welcoming and ready for different cultures to integrate. I feel like much of that has been lost. Maybe outside the metropolitan cities it was never there, I don't know.

I am confident that the real saving grace of British society, regardless of which end of the spectrum they are on regarding Brexit or immigration, is their love for the NHS. How or how much they want to fund it is a different matter, but actually the vast majority of the nation truly admire and appreciate the NHS. A society should be judged by the safety net it provides to those less fortunate, and the NHS does that: it helps to bind British society. If the NHS didn't exist in the UK, how many safety nets would there be?

I get the feeling England is moving more towards this sense of individualism rather than towards a cohesive society, and that worries me. There are very few safety nets and this attitude of individual aspiration, or ownership can be detrimental if we don't consider our shared fraternity. We should aim to do well in life but also contribute back to the society that has helped shape our own success.

Celeste Bell
Hastings

There is an underlying ugliness that permeates through our soggy soil – an ugliness born of bloodshed and conquest, bloodlines and class divisions and ill-gotten gains.

Irrespective of the aesthetic merits of England, there is an underlying ugliness that permeates through our soggy soil – an ugliness born of bloodshed and conquest, bloodlines and class divisions and ill-gotten gains. Yes, England is relatively safe and comfortable, despite the pockmarks of urban deprivation that scar the landscape. We cleared the countryside of peasants centuries ago, forcing them to toil in the first factories, forcing them into overcrowded city slums.

Then we cleared the countryside of predators. A rambler can rest assured that no bears or wolves will interrupt that oh-so-English of pastimes, the muddy country walk. The foxes remain, but what would the toffs have to rip apart if we had killed them all too? So, yes, England is safe and comfortable because we made her so. The Englishman made himself the ultimate predator, pillaging the world to fill the bellies and pockets of his betters. Britain was made beautiful, safe and comfortable for the enjoyment of the rich. I understood that from an early age.

I wasn't born rich, far from it, but my earliest years were spent in a beautiful bubble on the edge of London. I grew up in an intentional community, known in the vernacular as a commune. Inspired by eastern philosophy, the founders of our community attempted to recreate Vedic-era India in the English countryside. We had vast golden fields of wheat and corn and cows and goats and peacocks. We had a temple with marble floors, where saffron-robed priests made daily offerings to gods and goddesses. This little utopia smelled wonderful too, of incense and sandalwood and ghee and flower garlands.

We shut ourselves off from Britain, from the world. We were creating a new world. But no matter how lofty our ideals were, we couldn't stop the ugliness from seeping in. And, when I found myself catapulted from Zion to Babylon as an older child, I saw Britain with the eyes of an outsider. It was as if I not only had been living in another country all these years, but in another century, another age.

I felt like an alien in 1990s Britain. My mother had felt the same in the 1950s and 1960s, being of mixed heritage in an era where racial mixing was considered a sin. And I expect my Somali grandfather felt the same in the 1940s, when he stepped foot on our shores. Post-commune life in south London was hard to get used to. The children in my Church of England primary school seemed mean and cruel. I was shocked to discover that the British like to fight for fun and that bullying, belittling behaviour is passed off as banter, a celebrated national trait. There were no golden fields and peacocks here, just vast council estates and run-down terrace houses.

The sky itself seemed greyer and less forgiving here than in the commune. The cold seemed to bite more too. And life for the majority of my compatriots seemed to consist of going to work or school and coming home and watching television. Rinse and repeat. I wasn't allowed to watch TV in the commune. I quickly became addicted to it on the outside. But so was everyone else. It was as if life for many in the UK was only made bearable through escaping it via the telly, or alcohol.

As soon as I could leave Britain I did. I suppose I never formed a close enough attachment to the country of my birth. Britain for me is rather like my absent father, someone I see at Christmas and birthdays, someone whom I don't really know, someone who doesn't really know me. I didn't find a world free of ugliness outside the United Kingdom. I wasn't naive to think I could. But I found a kind of comfort in being truly foreign. Not the half-in, half-out feeling I had in the country of my birth. Being truly on the outside is liberating for me. I feel no pressure to conform or to try to belong. And the sunshine isn't too bad either.

PHOTOGRAPHER: LISA WORMSLEY

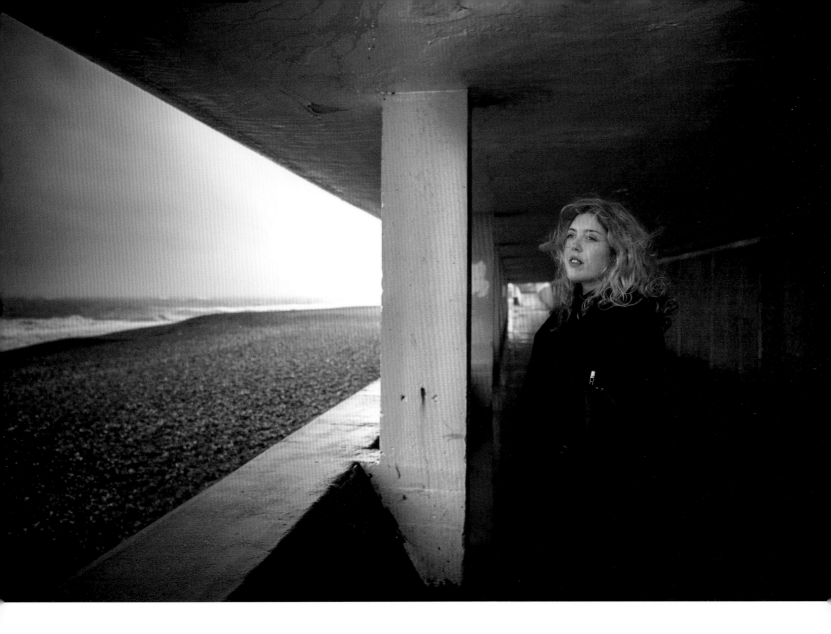

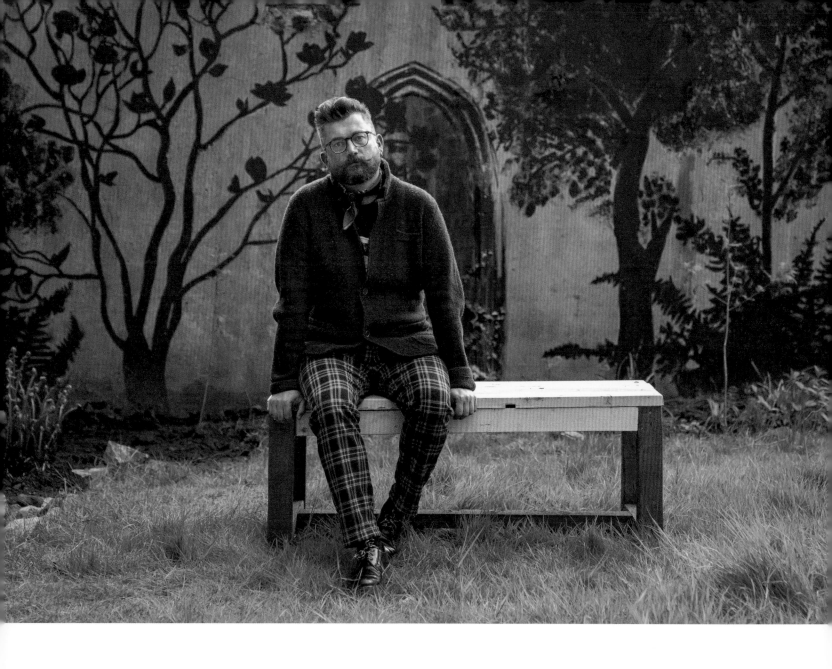

Robert Motyka
Edinburgh

I'm strongly for Scottish independence, because I understand it's not about breaking something. It's about actually having your voice respected.

I was born in Poland and lived most of my life there. I've lived in Scotland since 2007, in the Newington area of Edinburgh. This is my neighbourhood: I know the shops, I know my neighbours, so I feel at home. This place is very cosmopolitan. Close by we have a mosque and a Greek church, and I hear a lot of accents and languages outside of my window. I grew up in a very homogeneous country, and I really enjoy hearing different accents, having access to different cultures, different traditions and different cuisines.

I constantly think about who I am in so many different contexts. I feel Polish because I love Polish culture and Polish music – so this is my main ethnicity. I'm not sure if I'm allowed to call myself Scottish, as I wasn't born here, but at the same time I can call myself a Scottish artist because all of my art experience happened here. I work with projections and video and I wasn't doing any of those in Poland.

I grew up in a very homophobic country. I struggled with my identity for four years and I only found enough strength to come out when I moved out of Poland. When I was younger it didn't even cross my mind to have a same-sex relationship – it was a scary concept, I was afraid to be rejected by family and friends. I felt that, in order to grow as a person, I needed to run away. I couldn't imagine living as a gay person in Poland.

In 2014 I was strongly, strongly against Scottish independence. I listened to voices that said, if Scotland leaves the UK, we would automatically lose membership of the European Union. For me that was the main reason for voting 'no'. Being a part of something bigger is a valuable thing and should be cherished instead of creating divisions. Now I'm strongly for Scottish independence, because I understand it's not about breaking something. It's about actually having your voice respected.

During the Brexit vote, almost 70 per cent of Scotland voted for staying in the EU and this voice was completely ignored. What I find completely unacceptable is how Westminster is treating the Scottish government with such disrespect. Scotland is a very advanced, very pro-equality country, with developed technology and science. I think the only way for Scots to make the next step in the direction they want is to become independent.

The concept of the EU is mostly about the peace: it was created after the horror of the Second World War. The concept was: if we collaborate with each other, if we remove the borders, even if we still keep our differences, we won't be killing each other. The UK deciding to leave the EU is breaking the peace pact and also exposing this 'old British' colonial thinking of people in power. I hope to be able to campaign for Scotland rejoining the EU. The EU is not perfect, but the peace project is good enough for me, and freedom of movement, freedom of living and working wherever you want – I love this freedom.

When I consider the question of what 'Britishness' means, I think the term starts falling apart. I'm thinking: do you mean England, or do you mean Northern Ireland, or do you mean Scotland, or do you mean Wales? Because I know that English voters have different opinions than those in Scotland. I prefer to talk about Scotland, since I live here. I think Scotland is diverse in a sense that there are people from different backgrounds living here, but also there are still a lot of things which were never resolved. Europeans look similar to Scottish people, so we blend in easier, but people with darker skin still struggle with the lack of diversity in Scotland.

Scotland is working on the diversity issue, but there is still a need for a strong representation of minority groups, people of different colours in the Scottish government. As Europeans, we don't have any representation in the government – our voices are very often not heard. People don't even know what our struggles are. How many people in Scotland were aware that we couldn't vote in the Brexit referendum? I hope in the future there'll be more representation for people from minorities. We need more strong voices.

PHOTOGRAPHER: KAT DLUGOSZ

Simon Tyson
Dereham

In the UK there's lower class and higher class. We don't give a fuck about the higher class, and the higher class don't give a fuck about us.

I was born in Pontefract, but I grew up in Southampton and it was a shithole. The Old Bill made it bad for me then, stopping me from doing what I wanted to do. You know, if I wanted to do something they'd say, 'Simon, you can't do that.' And I was like, 'Well, yes I can.'

Not much has really changed in my lifetime. It's just got shittier. The cost of living just gets worse. You used to be able to buy a packet of ten fags for £3.50. If you go and get a packet of 20 now, they're over £10. Now you need, like, £300 a night just to go out and have a couple of drinks. I'm starting to think about getting a job. I'm fed up with it. If I'm lucky I'm left with a pound at the moment. So, I've got to get back to work.

In the UK there's lower class and higher class. We don't give a fuck about the higher class, and the higher class don't give a fuck about us. In Dereham, walking up Sandy Lane you can notice loads of difference. Sometimes I'll say 'thank you' to people and they'll just ignore me. And I think, well, I won't be saying thank you to you again then.

With the upper classes you get these snobs who wouldn't even share a drink with you. And then you've got poor people who give you water when you need it, because it's the poor people who appreciate it. If you haven't got it, you appreciate it. And, if they have got it, they don't give a fuck that they've got it. They just know that they've got it. I don't think that will change. Money talks. If I had money I wouldn't know what to do with it. The wife wouldn't know what to do with it. First thing I would do is go and do my house up. It's looking poor now. And I would probably invest.

The last year has been rubbish. Around this time last year I was admitted to hospital for a collapsed lung, so I've not really been able to go out and do what you normally would do. I've probably done what I would normally do anyway, just minus people coming round my house all the time. When COVID came along, considering what I went through last year and what I fought through, I was thinking to myself, well, if you're going to get it you're going to get it. Probably, if I'd have gotten it, that would be me gone. But I just thought, if it happens, it happens.

I don't follow the news. I don't care what goes on. I didn't even know that there was a lockdown until me and the wife were at my mate's house. We were sat around and he was like, 'You do realise we're on lockdown from tomorrow?' I thought he was taking the piss. Me and the wife looked at each other and said, 'This isn't prison.' So when he said there's a massive virus going about, I hadn't heard shit all about it.

Dereham is crazy now. People will walk out where there's traffic, where there are cars coming, and it's like, what, for a virus? But people walk on the road because they won't walk beside you. People walk in the middle of the road in town. It's insane. I'm worried for my wife more than me. I've got a mask, which I wear, but one day I went to the shop at the bottom of the road and forgot it, and I got told off. So I walked out, and just walked home. I'm just trying to get on with it at the moment, just trying to exist.

PHOTOGRAPHER: JIM MORTRAM

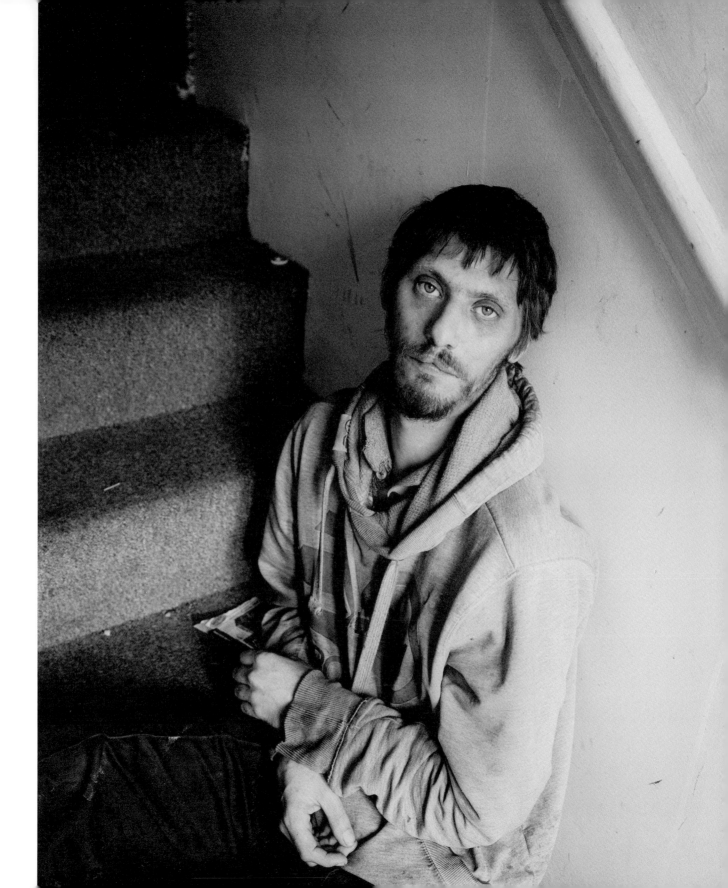

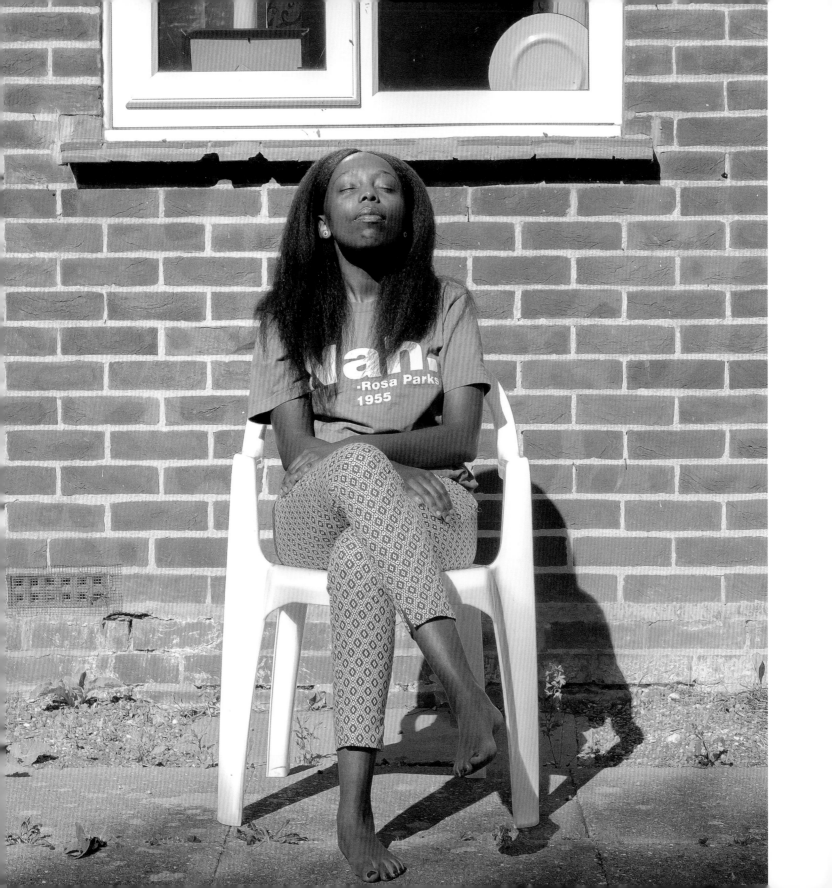

Joy Itumu
London

I still feel we are intentionally marginalised, tokenised and disproportionally underrepresented, despite the fact that our culture is aped throughout the western world.

My experiences of being a young Black female in this country have shaped my understanding and my opinions. I think that's why I'm very keen to hold on to my Kenyan heritage and values in a practical and intentional manner. I visit Kenya frequently, still speak Swahili and Kimbeere, and stay up to date with current events.

After my nursing degree, my first job was in Gloucester. I used to have experiences where patients would say nasty comments because I was Black. Some staff members also treated me differently compared to my colleagues, and a few intentionally frustrated my efforts during the times I had to be in charge of a shift. Brexit has exposed what people thought all along. I strongly believe there's nothing new about the sentiments that a lot of White people hold against ethnic minorities. People were emboldened to voice their prejudices under the pretence of a democratic exercise. They had an outlet, they used it and they really went for it.

If you're a Black person, no matter what happens with Brexit, you're still going to be Black in the UK, facing the same challenges you faced last year. The Black British population is very diverse, and I think we have a lot to offer. I still feel we are intentionally marginalised, tokenised and disproportionally underrepresented, despite the fact that our culture is aped throughout the western world. We are seeing some small advancements. We now have the first Black editor of *Vogue*. I'm not a fashion connoisseur, but this is culturally important for the next Black British designer.

I was watching a documentary set in Slough, where there's been an influx of eastern Europeans, and this middle-aged White couple were like, 'I don't recognise Slough any more. This is not where I grew up. This is not my town.' I tried to put myself in their shoes. You would be a bit perturbed if all these people started living next to you who don't speak the same language and whose culture is different to yours. Although this couple may have felt alienated, I still believe diversity sharpens and enriches us. There's also more to assimilating to British culture than the ability to speak English. I've heard many people might say, 'Yes, I'm integrated. I live next door to a Black or an Asian person', but real integration is not just about living next door to a neighbour who has a different skin colour. Integration requires a conscious effort that will put you in uncomfortable situations.

Immigration has created a lot of segregated neighbourhoods. An example is, if you're a White person who has never had interactions with Asians, you're unlikely to buy a house on a street occupied by Pakistani or Indian families. I think the only place that is integrated is some parts of inner-city London due to social housing. In the counties, I don't think anything's changed; for example, Gloucester is still very segregated; there's a part that's multicultural and then the rest is very White. You are definitely an ethnic minority there, and yet, when you look at the hospital wards, they are run by Asians and Blacks and I'm sure that replicates itself in most counties. If ethnic minorities were to down their tools today – and I'm just talking about nurses and healthcare assistants – the NHS would collapse. We have a massive impact on the economy and therefore are not here to be dismissed or belittled because someone feels threatened by the fact that we are excellent at our professions.

I think Black people want leadership: they want to be represented. That's what it means to be Black British, especially in the age of Brexit. I've been very fortunate to interact with a lot of Black people in this country from all backgrounds, and there is something really special about how they've evolved into this culture. How they've learned to assimilate but stay authentic to their culture. They've learned how to put on a mask, go to work but still have enough energy to engage as their true self in their personal lives. When I see a Black British person triumph or a trailblazer, I'm like, 'Wow', because they've made it, most probably with huge obstacles in their way. It's a special thing to be Black British.

PHOTOGRAPHER: MARIO W. IHIEME

Louis Beckett
Rochdale

The North has always been treated differently from the South and it's just got worse with those lot in power now. They're detached from reality, never mind from the North.

I live in Middleton with my dad, but I was brought up in Ancoats, Newton Heath, just down the road from Moston in Manchester. I'm working class from my mother and father, and then I went into engineering in a factory-floor environment. I was a shop steward, a convener, so I would class myself as working class.

Growing up in Newton Heath, everyone knew each other and the estate was good back then, but it's gone to shit now. There's drugs, a lack of community services, nothing for young people to do. All the youth services have been shut down and people were just generally left to their own devices. It was a great estate when I was ten years old. It's just horrible now. I don't think there's a community at all. It's hard for community centres, community services. It's hard getting people to come out of their houses to use the community places.

People are encouraged to sit in front of the TV and drink cheap beer rather than go out to a pub and have a couple of pints and sit for a couple of hours with their mates. Pubs have shut down because they are places where working-class blokes used to meet and put ideas together, not just because of the smoking ban.

The North has always been treated differently from the South and it's just got worse with those lot in power now. They're detached from reality, never mind from the North. I just think they're on another planet, you know. They're living in this world where it's money over everything, it's profit over everything, and stashing money away. I don't think they speak for any of us now, and I think the whole of the UK is coming round to the working-class way of thinking. Not just the working class but their own way of thinking. The next election these people can't get in again – no way.

It's more militant up in the North than what it is down South, in London anyway, 'cause until recently we've never voted Conservative. I thought we got treated fairly when Labour was in power. Everyone got treated fairly, the same. The Conservatives have been back in power for the last ten years and we can see it affecting us.

There was never any need for austerity. They didn't have to clamp down the way they did. The government always had plenty of money. They were saying 'There's no magic money tree' and then all of a sudden this COVID starts, the pandemic, everyone's locked down and they're throwing it away like confetti. Well, where did all that come from? Were they just going to stash that away into their hedge fund or whichever tax haven they stash it in?

I think it's become a selfish society. A lot of people are selfish, looking after number one all the time. Never thinking of the bigger picture. If we all looked after one another and we all got together the way we used to do – we brought governments down. With the poll tax riots we brought Thatcher down, didn't we? A lack of community works for them in power by cutting people off one from another. They've systematically done it, I think, by breaking the unions, shutting pubs down, shutting community centres down, cutting youth services down.

There's no meeting points. There's no big workforces. They've got people working for Amazon and all of the rest of them. They've got no rights. They're just working to make ends meet and they're being told, 'If you don't like it, fuck off, do one.' They've got no rights at all in work, so they can't get together and organise themselves and become more powerful.

PHOTOGRAPHER: MARK PARHAM

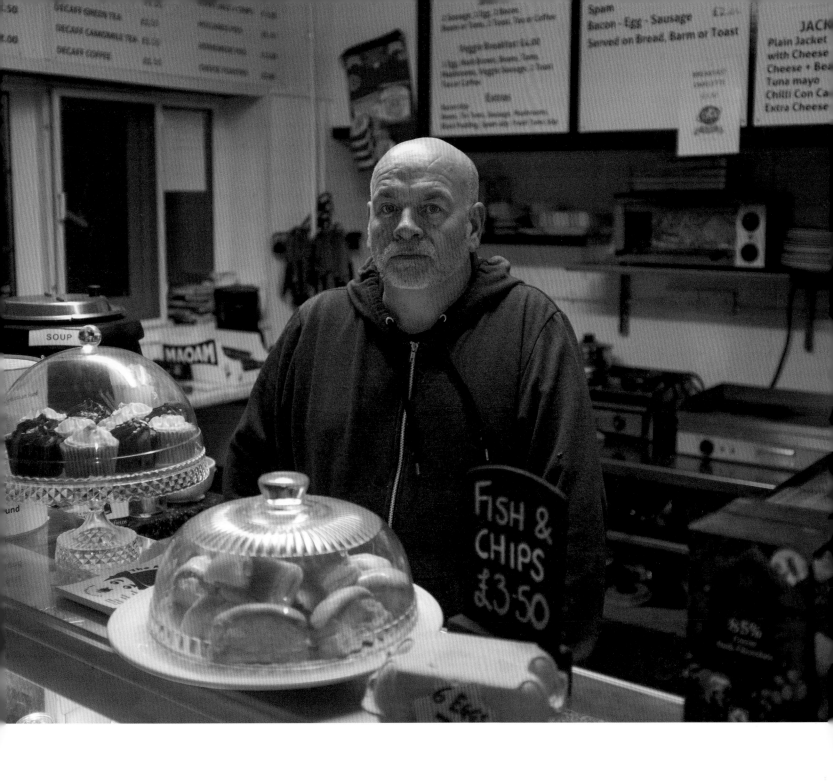

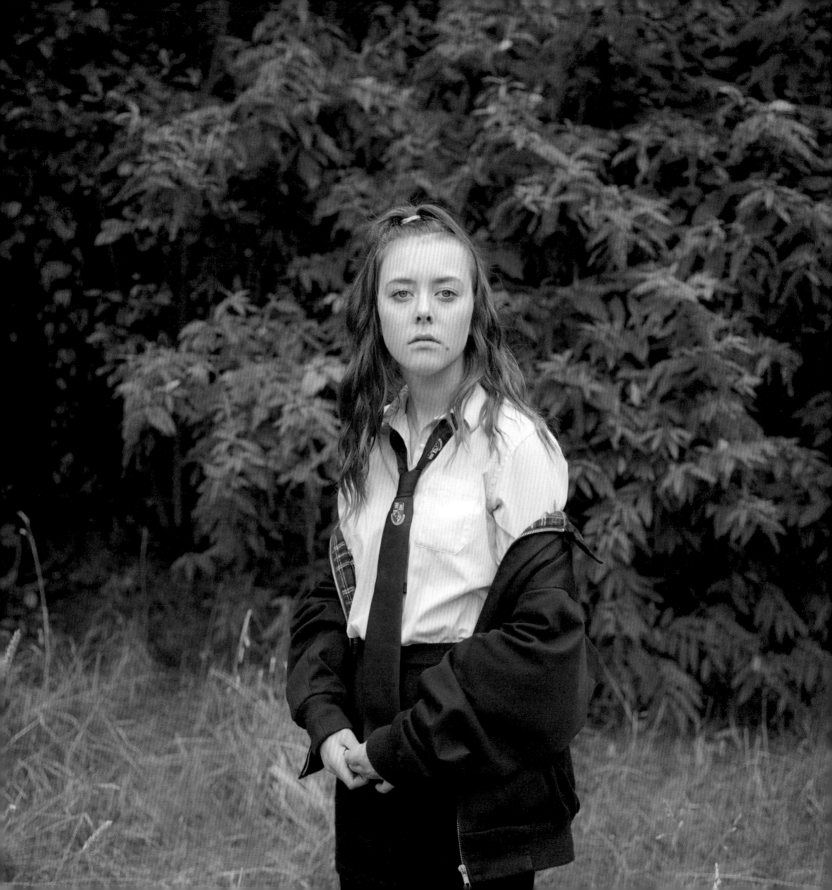

Stina Fisher
Glasgow

At the moment it's young people who are trying to make a change even though it's not their fault that things are like this.

I was born in the Queen Mother's Hospital in Yorkhill. My mum is from a small town in Germany and my dad was born here and moved around Scotland with his family for a bit. When people ask me about my nationality, I don't know whether to say Scottish or German. I know I don't feel British though. I am Scottish and German but it's a bit confusing which one to say. When I was younger, I felt more German as I watched all the German World Cup games, we used to go to German kinder club, and my mum always spoke German with me while my dad was at work. I never really thought about my nationality growing up but I think it's a good mix.

When Brexit happened, I was furious. I didn't understand how the government was coming out with these unfounded accusations and everyone just believed it. I also don't think I really understood or think we were actually going to leave because the idea sounded so pointless. I was also upset when I got my British passport recently as I didn't want one, but we decided I should have it just in case. People always say that it's really cool to have a mixed nationality and be bilingual, and I agree: I'm so lucky because I basically have two homes. I have citizenship here but I also have one in Germany. I feel like I belong to both countries.

I first became interested in environmental issues when I heard about a demonstration happening in George Square in Glasgow. My family has always been very conscious of their carbon footprint and the environment. My gran and her friends used to go to protests all the time and she even used to chain herself to gates and sit on the road blocking cars. She was always encouraging us to go, telling us to fight for what we believe in and there's no point in us just sitting here not speaking up.

The idea for the first protest was to just stand up in the middle of the lesson and march out of school. However, the staff found out about it and were standing at the gates, screaming at people to get back inside. In the end I had to phone my dad to prove he was allowing me to skip school! When we finally got out, we got some of our siblings from the primary [school] and got the subway into town. There were around 100 people at the first protest, but as the weeks went on more and more people would join. Protests give me so much adrenalin.

Afterwards I joined Extinction Rebellion Youth Glasgow, and we would meet up together and plan events like die-ins, which is where you lie on the ground pretending to be dead, surrounded by posters. At one lie-in I almost got run over by a van just outside the big John Lewis in town. The guy had to get out of his car because we were on the road, but the main idea is to get attention. I have discovered that some people just don't want to change their mind. They start shouting or arguing with you, but it's not like we're doing it for fun. It doesn't matter what race you are, what age you are, if we don't make a change, we're all going to die.

The people in power just want to make rich people richer and poor people poorer. The world revolves around money in their eyes and, as long as they are wealthy, they don't care about helping others. You need to be ruthless to get to the top. At the moment it's young people who are trying to make a change even though it's not their fault that things are like this. The people who should be making a change are the people whose fault it is, the people in power, but they're not listening. It's not their future that's going to be affected directly; however, it will affect their kids and grandchildren. I think everyone needs to take action now before it's too late.

PHOTOGRAPHER: MARGARET MITCHELL

Owen Haisley
Manchester

The first time I was almost deported, I came within 20 minutes of being put on a plane . . . At the last moment, the deportation was postponed.

I was four years old when I left Jamaica in 1977, and I've never been back. My mum, a nurse, brought my sister and me to Britain for a better life. Life can be a struggle over there, so she seized the opportunity. Growing up in London, I was aware of racism but just tried to crack on with my life. I know my roots. I don't need to put labels on myself. I'm just a Black British person.

The first time I was almost deported, I came within 20 minutes of being put on a plane. I was holstered in a van with three security guards, waiting for my lawyer's appeal to reach the right department. At the last moment, the deportation was postponed. My first contact with the Border Agency was in 2016, while I was serving a one-year prison sentence for domestic assault. I was told I could be deported under the government's hostile environment policy. My indefinite leave to remain was revoked. I was released on immigration bail and required to visit a Home Office reporting centre every week. I can't work and was prevented from using the NHS or claiming benefits.

At first, I thought everything would work out, as I'd lived here for so many years. But in August 2018 – 12 months after my release – I was detained and warned I would be deported within days. I didn't tell anyone because I was embarrassed about my situation. I felt very alone. My lawyer appealed on human rights grounds, leading to my release, and submitted an application to the Windrush Scheme, which was rejected. Then one day they detained me again. I was taken to a detention centre and, once again, was warned I would be deported within days. This time, I went public and friends campaigned on my behalf. I am an MC so have contacts in the Manchester music scene, but I couldn't believe the support I received – 100,000 people signed a petition in one week and my MP, Lucy Powell, spoke on my behalf in the House of Commons. I was released a day before my scheduled removal, but 30 other people weren't so lucky and were deported.

I'm still living in limbo today and the pressure on my family is enormous. I was told my children – then aged five and seven – would be okay without me and that I could bring them up over Skype. I had to tell them daddy needed to go to Jamaica and may not see them for a while. That conversation almost broke their hearts and they've lived in fear ever since. If I don't answer my phone they worry I've been taken away. My mum lost her husband to cancer while this was happening and now worries about losing me. She feels let down by this country. This is the first serious thing I've done wrong; I'm not a re-offender. If I had a British passport I'd be given a second chance.

All I want is to get back into work, get a house and do normal things with my children. Instead I'm reliant on friends and family. I've had to find my own coping mechanisms. I go to the gym, listen to music, talk to my kids and keep in touch with the guys I met in detention. I'm trying to stay positive, but when I get time on my own it hits me. If I don't keep myself busy, I might fall apart.

To be honest, I'm disappointed in the way I've been treated by the system, which I think sets people up to fail. If people have done what's asked of them, why can't it end there? I don't blame the country for what has happened to me though. It's racist, discriminatory people who have set certain policies up. I can't blame the masses when it's the few.

My boys have mixed heritage and I'm waiting for the day when one of them comes home and tells me they got called some offensive name. But I'm getting them ready before it happens. I'm telling them they're like everyone else but are going to get people who will call them different names and they mustn't get angry. They are growing up in a predominantly White area. When they're with me I show them their Black side, their Jamaican roots, the food and music and all of that so they get a balance and can work out their identity for themselves when the time comes.

PHOTOGRAPHER: CIARA LEEMING

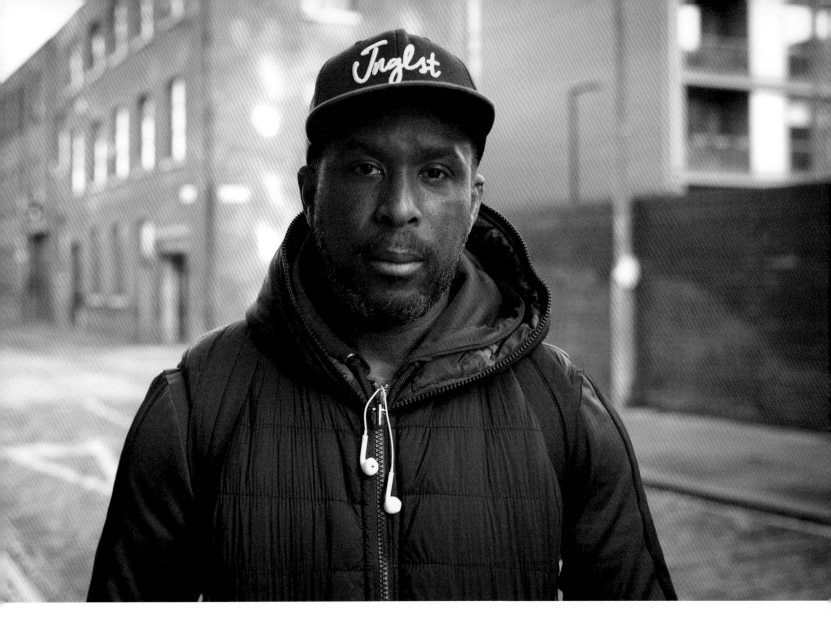

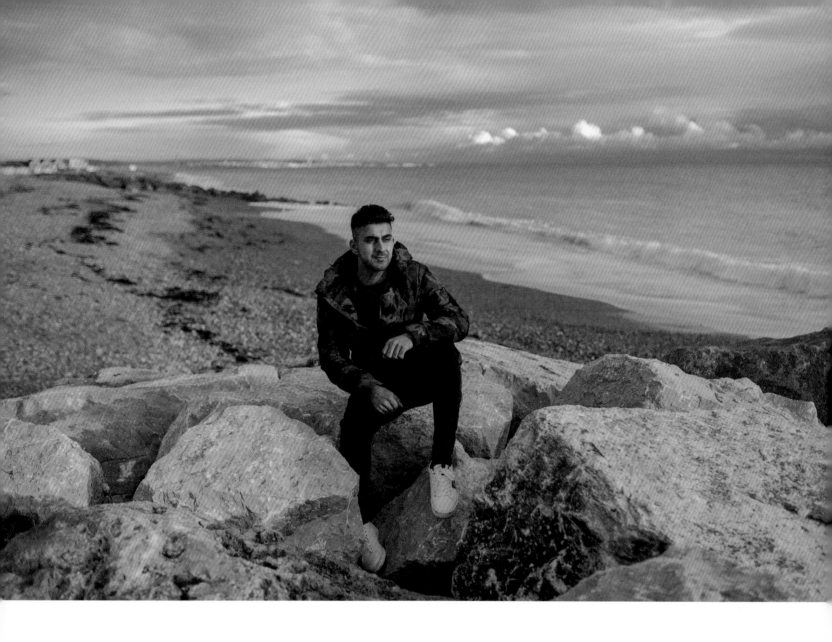

Naqeeb Saide
Worthing

Most people who arrive here want to work hard to build a new life and contribute back to the country. We just want a safe roof over our heads.

I left Jalalabad in Afghanistan four and a half years ago to come to the UK. From the moment you arrive and register with UK Visas and Immigration, most of the things you do are recorded on the system. Asylum seekers often feel scared because we always feel like somebody is watching us. If you arrive by plane, they ask you where you came from and give you an identity card. They tell you they want to see you in three months for a second interview. It never happens. They also say the whole asylum process will be done and dusted in six months. This also never happens. In fact, mine took three and a half years.

To get asylum-seeker status there are two interviews. The first interview normally takes a long time to happen, but because I came by plane, I had it at the airport. The second interview can take four hours. They ask you for a lot of information and require exact details. If you're waiting two or three years for your interview, how can you be expected to remember every single date and time you did something?

The Home Office also asks you for a lot of proof and evidence. Despite my sending them as much evidence as I could, they didn't even check the proof I provided – they just refused me. They also ask you for proof that you're in danger back home, but how can I provide that? I can't contact the people who are after me to send letters saying that they are after me. If your asylum claim is refused, you then have to file a fresh claim or accept that you must go back to your country. If the judge accepts you they still give the Home Office 14 days to appeal. If the Home Office appeals it means the visa is not valid, so you go back through the same process all over again. I only had my decision a year and a half ago. Thankfully, Caroline Lucas, the Green Party MP, helped me and sent letters to the Home Office. Even with her support, it still took a long time.

My family chose the UK for me because my brother was already here and they knew he would look after me. I think it's important to go to a foster family when you arrive. They help you to learn the language, teach you the culture and show you how to speak with the people. If I had arrived and gone straight into independent living, I would've been lost. In my country, we don't pay tax, we don't have things like a TV licence. So, it's good that there's somebody to look after you and to teach you what to do and how to do it.

When asylum seekers try to find a safe place where we feel protected, we often lose our families. Once settled in we try to find our families by asking for help from the Red Cross and from the local community. It is always difficult to build a new life in a new country, especially when your family is not around. You feel hurt and upset, especially during the festivals, when you see everyone enjoying their holidays with their families while you stay by yourself in your room.

I joined the Hummingbird Project in 2017 and became a part of the Young Leaders group. We work together to raise awareness around the issues facing young refugees. We meet with MPs, schools and colleges to help create positive change. Some of our greatest achievements include winning a Parliamentary Award in 2019 for Community Campaign of the Year and speaking at a Kindertransport Anniversary event in front of MPs, celebrities, charity leaders and young people. This year we were also invited back by the Houses of Parliament to judge Your UK Parliamentary Awards 2021..

Most people who arrive here want to work hard to build a new life and contribute back to the country. We just want a safe roof over our heads. When I first arrived, I tried to learn as much as I could, do new things and meet new people. It's hard for us when we don't have our family. If people would give us a chance, we could prove that we are educated and talented and we can contribute back to this country.

PHOTOGRAPHER: ALECSANDRA DRAGOI

Garn Jones
Anglesey

I think Welsh independence will be something that we'll need to talk about much more compared to previous years when it's been pushed aside.

I live on an island in Wales connected to the mainland by two bridges. It's quite rural, but I couldn't imagine myself living anywhere else in the world. I love the area. My nationality is Welsh. I don't particularly feel British. I've lived in north Wales most of my life – I've got my roots here. I received all my education through the medium of Welsh, most of my family and friends are Welsh speakers, and now I teach in a Welsh-speaking school. It really informs my identity, the fact I am surrounded by Welsh speakers all day.

I think Welsh independence is quite an exciting prospect. In the last year it has moved from something I speak about with my mates in the pub on a Friday afternoon or evening to something that's in the forefront of people's minds and in the media. It's exciting to see how much further we can take this in the next year or so, especially with the local referendums coming up on 8 May. I think that will be really interesting. I think Welsh independence will be something that we'll need to talk about much more compared to previous years when it's been pushed aside.

I was fortunate to be living in Cardiff while I was at university, when YesCymru had what I think was their second march. So I participated in that one. And then in 2019 they had their largest crowd ever in Caernarfon and that was pretty special, to have so many like-minded people marching together all for one cause. You really did feel a sense of identity, like we're all pulling together on this. I've never experienced anything like it.

At the end of last summer, I got the opportunity to start working at a local secondary school. It's a Welsh-speaking school where I am supporting kids that have missed out on a large part of their education during the first lockdown. They were quite behind on a lot of work. I've got three or four kids under my watch and I help them with their education. Either they've really struggled to get back into full-time education after so much time off or they've just fallen behind due to various reasons. It's a rewarding job seeing these kids fulfil their potential. I wouldn't be in this situation if it wasn't for the pandemic, so even though it has affected me in lots of ways, this is a silver lining.

When I was young, we learned a bit of Welsh history in school, but it definitely wasn't at the forefront of the curriculum. For a young Welsh person now learning about Welsh independence, I think it's important to realise what has happened over the years with regards to England and Wales. And then appreciating that history, accepting it, learning about it and using that to inform your sense of identity and the future of Wales being an independent country.

I feel that, being a developed nation, we should all be doing our bit to help other people when they are in need. I think that's just human and shouldn't need to be discussed. It's about giving people a chance to fulfil their lives rather than living scared or having to leave their homes for any particular reason. I would like to think that Wales is quite a welcoming country and that we welcome immigrants more out of duty than for political reasons.

Britain's colonial past is something that British people shouldn't shy away from. We've got to accept it and be active in learning about the effect it had on the local communities that the British took over, and learning this from their perspective as well. It's important to appreciate the other side of the story, which isn't always taught in schools.

PHOTOGRAPHER: ROBERT LAW

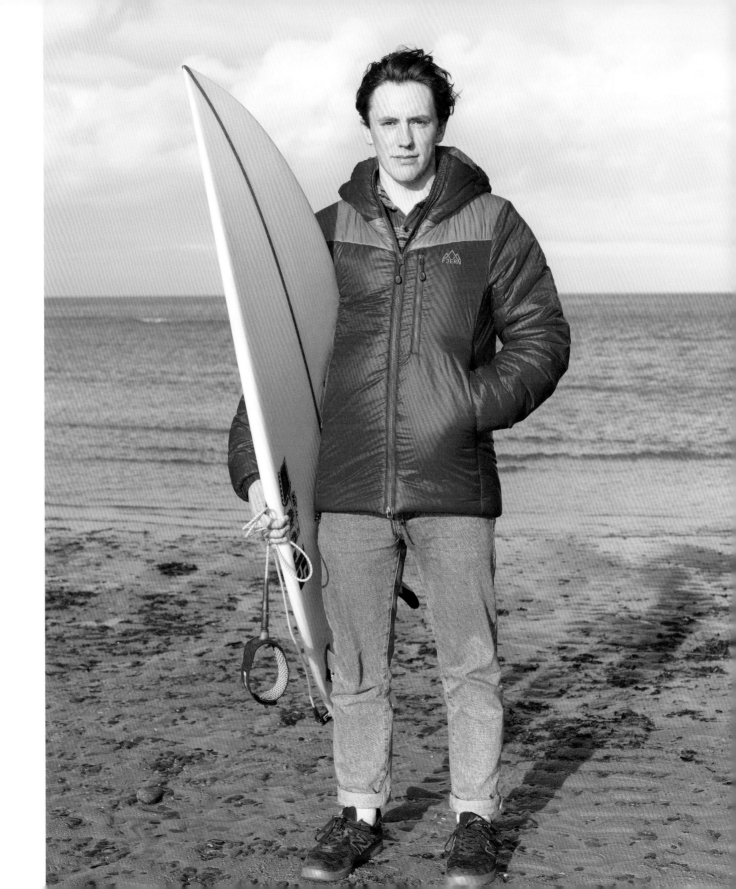

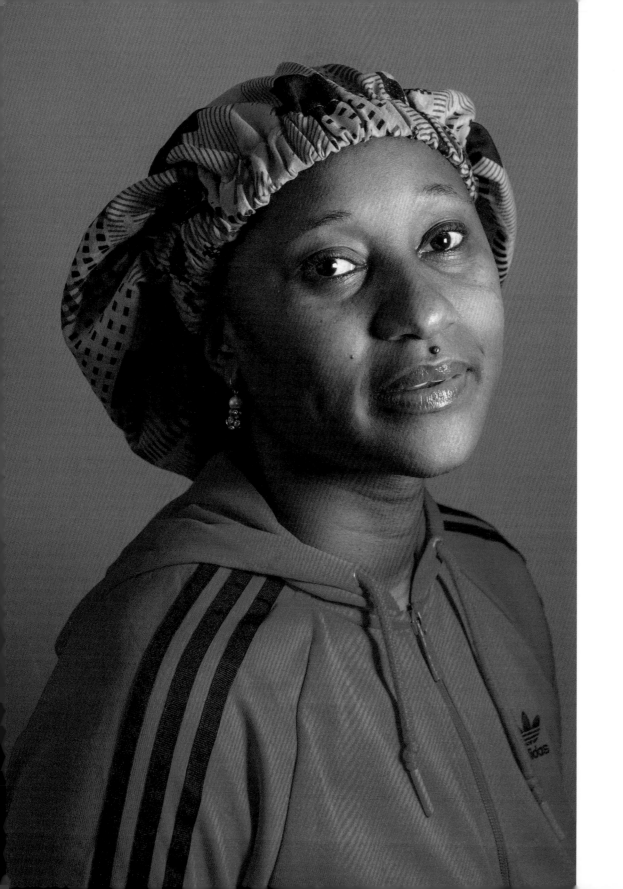

Uche
Newham

Britain's colonial past is quite painful for me ... It's like going into someone's home, taking the wife, the husband, the kids, and doing whatever you want with them.

When I first arrived with an intent to live here, I was young and naive. I had a picture of what I thought Britain was, and it wasn't what I expected. I went straight to boarding school, and that's what I thought England was. I thought England was sending your kids to boarding school, they get educated, and then they come back home and run the business. That was the plan.

When I started moving back and forth between Devon and London, I could see the differences. I was like, 'Hold on a second, it's not the same as where I'm coming from.' I was privately educated, but I felt that I didn't fit in because I was from Africa. There were four Black kids in the school. When I came to London, I would see Black people and that made me think, 'I'm definitely moving to London when I'm done here.' I had never worked before, and I found out that you have to work in order to survive in this country and be seen as an upstanding member of the community. I was like, 'Any job. I'll sweep, I'll clean, I'll do whatever. I just need a job.' Living among people like myself, that came over to get a better life, people that have left their homes, their security, their loved ones, helped me a lot.

I've always loved English humour. I watch *Fawlty Towers*, *Only Fools and Horses*, *Some Mothers Do 'Ave 'Em*, and those shows are so hilarious. If you watch stuff like that, it might not make sense to you at first, but if you continue watching you start to get the humour. You get what's behind it, and the stiff upper lip, but they are funny as hell. That's where I got my humour, my accent and just generally being able to blend in. I can speak Cockney, so when I'm down the shop and you've got the guys sitting around the cafe, I can have conversations with those guys. They're hilarious. I'm like a little chameleon.

When it comes to Brexit, I didn't agree. I voted 'stay' because I believe in *ujamaa*. It's Swahili for 'familyhood', 'family', 'community', 'community spirit', coined by Julius Nyerere when they got independence in Tanzania in 1964. It's coming together and looking after one another. I believe so much in that and where we had the European Union I could feel that. You could travel to Spain, you have one currency, you felt like family. You're like 'Hola! I'm just here for the weekend!' But they took that away from us. When you divide you start to separate people; 'Together we stand, divided we fall.' I'm not happy with the division, the separation. It's like, 'Go back to where you came from.' It's created this separation and division and everyone's suspicious again.

Britain's colonial past is quite painful for me because of what we learned in school. In Africa, our history, like European history – it was mostly colonisation. It's like going into someone's home, taking the wife, the husband, the kids, and doing whatever you want with them. That's how I felt. And then saying, 'Oh, don't worry, God is still going to look after you, I know I killed your daughter yesterday, but you still have to be good.' That changed people's family structures, people's identities, people's culture, people's sense of identity.

When you're taken away from what you know and taken away to somewhere different, and there's no one around that you can say, 'That person looks familiar – maybe they speak like me', it's like cutting the umbilical cord. It changed the course of history, people's perceptions of themselves and perceptions of White people or British people, or colonisers, or whatever you want to call them. It changed economies. Africa has every resource you could think of but look at the state of Africa. Look at the corruption. That's what that created. People have lost their sense of identity – who they are and where they belong. Hence the Black Lives Matter movement. Right now, we're trying to learn ourselves again. We're trying to find out who we were, what we were and the impact that has had on our future and our future generations. Everybody's trying to learn about themselves all over again.

PHOTOGRAPHER: MARC DAVENANT

Maciej Rackiewicz
Peckham Rye

There are different ways that immigration impacts a nation, but living together with many people from different races, different nationalities, different religions – it's definitely had a very good impact.

I was born in Poland and I lived there until I was 26. I moved to London 12 years ago. I don't think I really relate to being Polish in my daily life. I don't really think about it and don't really celebrate my Polishness. I maybe even try to avoid the Polish people. I don't cook Polish food. I don't go to Polish shops.

When I left Poland I didn't want to bring that old identity with me. I wanted to shed it and create something new for myself, because maybe I wasn't quite comfortable with myself in Poland. There's a little bit of shame and an inferiority complex, which I think a lot of people from my generation from eastern European countries still feel, although I very happily admit to everyone that I'm Polish.

The main reason why I moved here was because of university. I had studied chemistry in Poland, but I always wanted to study art and design, which is why I decided to come here. I felt that there were more opportunities for higher education here than in Warsaw. At the very beginning I think living in a big city like London impacts you in a way that you feel more lonely and disconnected from other people. For most of my first years I was suffering from loneliness. I didn't have many friends and I found it quite difficult to socialise.

I couldn't vote in the referendum, but if I could I would definitely have voted 'remain'. I'm quite proud of the European Union. I think it's a good institution. It's good that it's there. It's not perfect, but I think Britain is making a really big mistake in leaving. You hear a lot in the media about people being aggressive towards foreigners, especially from the EU. But I haven't really experienced that at all because I live in London and London is overwhelmingly pro-remain.

The UK is a nation of immigrants. There are different ways that immigration impacts a nation, but living together with many people from different races, different nationalities, different religions – it's definitely had a very good impact. I can see that in the differences between Poland and Britain. I definitely see British people being more tolerant than Polish people, and I feel that it's because people live next to people who are different from them, and they get to know them, they speak to them, they are neighbours. To me that's the best impact immigration has on a nation, compared to a country that has almost zero immigration. It's a great plus.

I live in Peckham Rye at the moment. It's a very diverse area. I see changes on a monthly basis in the sense that there are new people coming in and new businesses opening up, which are directed towards more wealthy people. For the foreseeable future I'm still planning to be in London, although I'm becoming more tired of it. I'm definitely applying to stay here for at least another five, six years. Later on, I'm thinking about moving somewhere very quiet – a quiet village – perhaps not in Britain. If I could earn money from home I would not have to stay in a big city for my job. I would prefer to go somewhere, maybe some other place in Europe, somewhere very quiet in the countryside.

PHOTOGRAPHER: MARIE SMITH

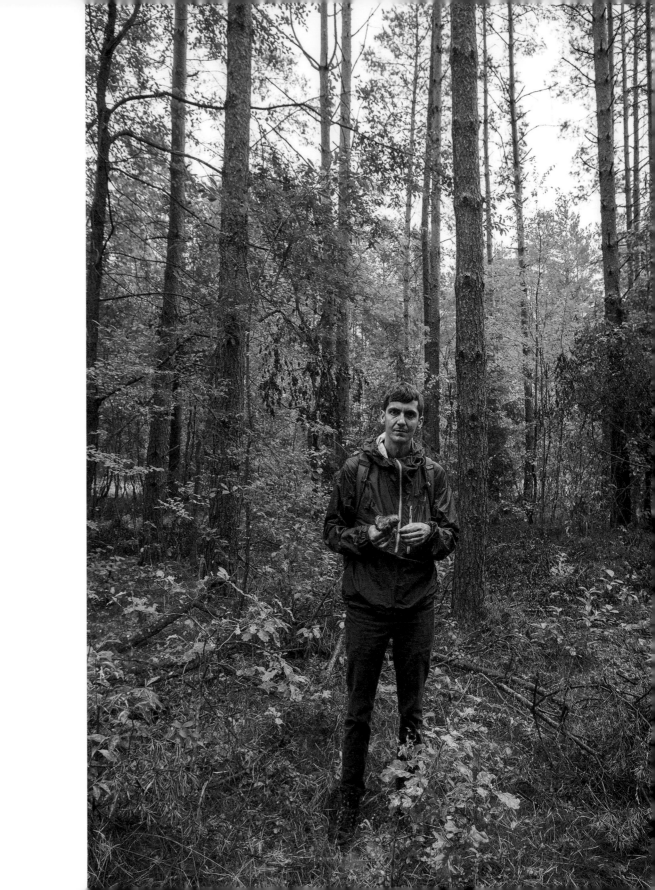

Dhadon Dorjee
London

Since COVID-19, there has been a lot of racism against east Asians … I'm not Chinese, but because I am east Asian, people perceive me as Chinese, especially during the pandemic.

I was born in Walthamstow but I lived in India for around a year when I was two years old. It was mostly just Tibetan people, and it was a really homely feeling. In my school in the UK, I was one of three east Asians in my year group. I would sometimes feel disheartened knowing there were no other Tibetan people around me. I like feeling reminded that I'm from a country, well, a used-to-be country, where there was cultural genocide and religious genocide. I like being part of something bigger.

My mother and father were born in India. Whenever they said, 'You're a woman, you need to do the dishes', or something specific that I should do because of my gender, I never really understood that. Growing up in London and learning about gender equality, I could inform my mother and father that this is wrong. Over the years my parents have definitely adapted to a more modern way of thinking, allowing me to choose my own goals and aiding me to work towards achieving them.

Before I started school, I was scared that people were going to ask, 'Are you Chinese?' and 'Where are you from?' They were a lot more welcoming and open than I expected. In primary school, people would say 'Isn't Tibet a part of China?' and 'So, you're Chinese?' It was obviously out of ignorance – they didn't know because they were kids. They just disregarded the issue. But when it was about the Tibetan issue, I was quite timid. I knew the history and I understood the Tibetans' suffering and everything, and it annoyed me that I couldn't stand up for myself. Nowadays I'd be more confident. I'd speak up about it.

East Asians are a minority but being a Tibetan is a way larger minority. In England there are at most five hundred Tibetans. I don't think there is any other nationality that I would rather be, because I feel so proud of it.

Whenever we have gatherings, it is so different. It's unique – the dances, the language, everything. It reminds you that you are Tibetan, that you have to speak your mother tongue. You shouldn't forget that because the Chinese government is trying to get rid of the language. I think it is a responsibility to be Tibetan, especially for the youth.

Living in London, it's very diverse. You go out and you see all different cultures and religions and nationalities, people wearing their traditional or religious clothing. I really like living in Waltham Forest because even just at the market you see different types of people talking different kinds of languages. You have a fruit-seller from India and a barber from Uganda. I once went outside London and was surprised to see so many White people. It's not a bad thing of course, but in London you just grow up with so many diverse people. I think they were still inclusive because they still had the same smiles and everything. It was a nice experience.

Since COVID-19, there has been a lot of racism against east Asians. I remember feeling so anxious 'cause there was a hate crime in Oxford Circus, against a man who was Singaporean. I'm not Chinese, but because I am east Asian, people perceive me as Chinese, especially during the pandemic. I felt more vulnerable, I guess.

During quarantine I was happy not to be going outside so much. It was really bad, and I wanted to hide away. But then with reopening and going back to school, I remembered that British people are actually quite inclusive. I forgot that there's always going to be a few bad apples anywhere in the world. That's just how it is. If I go out to Oxford Circus now, I don't feel scared, because I know that the majority of people are good.

PHOTOGRAPHER: SALLY LOW

PHOTOGRAPHER: RHYS BAKER

PHOTOGRAPHERS' BIOGRAPHIES

Adeola Adeko is an interdisciplinary artist, which stems from her curious and indecisive nature. She possesses an innate passion for creativity, design and innovation, and often chooses the medium of photography not only as an escape, but because she believes it lies at the intersection of her practice. Inspired by idiosyncratic beauty and the ability to freeze moments in time, Adeola ultimately aims to tell emotive stories through her photographs.

Andy Aitchison is an award-winning documentary photographer specialising in social justice and environmental stories and campaigns. He works for a wide range of clients, from community-based organisations, charities and NGOs to philanthropy foundations. His work is regularly published in some of the world's leading news titles.

Kris Askey is a photographer from Birmingham who explores people's identity, intimacy and everyday life. His work combines portrait and documentary practices that aim to show a lived experience, and he experiments with both digital and analogue processes. He has worked on commissions for the NHS, Apple and Coca-Cola.

Rhys Baker is a photographer based in the north-east of the UK. His work is often urban, occasionally coastal or rural, and contains a narrative and mystery which offer conditions for translation and scrutiny. His images are intended to act as containers of social experience, illustrations that activate self-analysis and remembrance.

Alicia Bruce is a working-class photographer, community collaborator, educator and activist based in Scotland. Her photography sits between documentary and staged imagery focusing on communities, environments and human rights. Alicia's photographs are held in several public collections including the National Galleries of Scotland, the University of St Andrews and the RSA.

Joanne Coates is an award-winning working-class documentary storyteller who uses the medium of photography. Based in the north of England, she is interested in rurality, working life and class inequality. She has shown work internationally and across the UK and is currently artist in residence at Berwick Visual Arts and Newcastle University.

Inès Elsa Dalal is a documentary photographer of mixed heritage, committed to countering anti-Blackness, hostility towards migrants and xenophobia. Dalal believes in ethical, long-form, meaningful projects, and works to co-create portraits rather than dictate the way sitters are photographed. Her photographs are exhibited in archival collections across Britain. She tours solo exhibitions nationally and lectures internationally.

Marc Davenant is a documentary photographer who works with marginalised communities and uses photography to highlight social inequality. He takes a participative approach to documenting people's lives, involving them actively in the creative process. Projects include 'Outsiders'. which explores issues of homelessness and 'Rebellion!', which documents climate change activism.

Kat Dlugosz, originally from Poland, is a photographer and a video maker based in Edinburgh. Her work is often inspired by social and political issues, with a special focus on feminism, identities, migration and the effects of politics in people's lives. Enabling the subjects to add their own voice to the conversation is an important part of her practice.

Alecsandra Dragoi, originally from Romania, is an award-winning photographer and photography tutor based in London who balances commissioned and commercial projects with personal work that has a strong focus on immigration and the Romanian community. She is a contributor to the *Guardian* and an official BAFTA photographer.

Amara Eno is a photographer from London. Her work aims to initiate dialogue between audiences and to empower those who often feel marginalised by mainstream narratives. Most notably, Amara has been recognised for her long-term documentary work in progress, 'The 25 Percent', which explores the multi-faceted landscape of single parenthood in the UK.

Mario W. Ihieme is a photographer from London. She uses a documentary approach to narrate the changing dynamics of cities and its implications for communities. Her work centres on the communal experiences of her Nigerian upbringing, and on similar experiences in other cultural bubbles, and aims to stir feelings of collective nostalgia.

Christine Lalla is a photographer, filmmaker and Londoner. Her latest project, RIGHT HERE | RIGHT NOW, is a series of portraits of underrepresented directors working in film, TV and theatre. Her background is in sports and automotive reportage, and her work has been published in GQ and *Esquire*. Her exhibition commissions include 'Moving Objects: 30 Years of Vehicle Design' at the Royal College of Art.

Robert Law is a photographer based in North Wales. He practises documentary photography, capturing both rural and urban environments and the people within them. Rob's work was shortlisted for Portrait of Britain and the British Photography Awards 2019 as well as the Urbanautica Institute Annual Awards 2020.

Ciara Leeming is a photographer and journalist based in Manchester. She balances commissioned writing for publications such as *Big Issue North* with independent photography projects. She often collaborates with groups that are poorly served by mainstream media, including Roma migrants to the UK and indigenous Gypsy and Traveller families.

Chris Leslie is a photographer and filmmaker who produces long-term multimedia documentary projects. 'Disappearing Glasgow' documented his home city of Glasgow and stories of the people on the frontline of demolition. His latest project and book, *A Balkan Journey*, is a 25-year collection of his photographic journey through the towns and cities of post-conflict former Yugoslavia.

"These portraits are a battle cry against the intolerant, the bigoted and the ignorant. They weave a tapestry of hope, diversity, love and humanity in all its fragile yet beautiful glory. This is my Britain."

PATRICK JONES, WRITER

Jenny Lewis is an award-winning portrait photographer whose work often champions women's voices and the underrepresented. She has worked for over 25 years, successfully publishing three photographic monographs. Her portraits are an authentic representation of her subjects in their own homes, workspaces or local environment. She has developed a strong visual language for the historical documentation of the way we live.

Sally Low is a documentary photographer and cinematographer. Many of Sally's projects engage with communities affected by industry or development. These are often communities living in 'forgotten areas', where increased levels of poverty, and health and social issues, make them an easier target for exploitation.

Gina Lundy is a Bristol-born photographer based in Glasgow, whose work spans genres, mediums and methods. Her creative approach aims to challenge dominant narratives and to playfully suggest alternative readings. Gina works as a freelance creative and tutor in a range of educational settings.

Kirsty Mackay is a Scottish documentary photographer, educator, activist and filmmaker based in Bristol and Glasgow. Her approach focuses on intimacy, trust and vulnerability. Her research-led documentary practice goes beneath the surface of issues including poverty, suicide, addiction, housing and class inequality.

Maisie Marshall is a documentary and editorial photographer from Cornwall. She is passionate about capturing changes in society and their effects on people and places. She uses her work to bring exposure to the voices that are often underrepresented in society.

Margaret Mitchell is a Scottish photographer based in Glasgow, whose work ranges from explorations of communities and children's worlds to long-term documentation projects on environment, opportunity and social inequality. Her work is held in the permanent collection of the National Galleries of Scotland. Her book *Passage* was published by Bluecoat Press in 2021.

Jim Mortram has been photographing for more than a decade the lives of people in his community who, as a result of physical and mental problems and a failing social security system, face isolation and loneliness in their daily lives. His work covers difficult subjects such as disability, addiction and self-harm, but is always imbued with hope and dignity, as he focuses on the strength and resilience of the people he photographs.

Nicola Muirhead is a documentary photographer and visual storyteller from the island of Bermuda. Her practice explores the complexities of identity and place, and how communities and beliefs are shaped by political, environmental, historical and socio-economic factors. Independent projects are research led and collaborative, using experts and the testimonies of a community to tell their story.

"An essential document that shines a light on alienation within a divisive society. History books shouldn't be about kings and queens and class hierarchy, but about the challenges of everyday life, humanity and belonging – real stories like those in this book."

PAUL WRIGHT, BRITISH CULTURE ARCHIVE

Kate Nolan is an Irish visual artist based in Dublin who focuses on extended photographic stories that examine the nature of identity. Drawn to 'in-between' places, she is intrigued by the effects of the shifting histories of areas in flux. She collaborates with local communities over extended periods to consider and evoke the nuance of change.

Mark Parham is a Salford-based photographer who aims to uncover forgotten or unseen narratives. He is engaged in an ongoing exploration of what ultimately makes us human.

Faraz Pourreza-Jorshari is a photographer based in London. He focuses on creating intimate, long-term projects involving themes such as identity and home. His new book, *To Sea Again*, focuses on a group of ex-fishermen and their unified sense of government betrayal over the collapse of their industry.

Yan Wang Preston is an award-winning photographer known for her ambitious, research-based work dealing with the politics of nature and landscape imagery. Her projects include 'Mother River' (2010–14), for which she photographed the entire 6,211 km of the Yangtze River in China at precise 100 km intervals.

Roland Ramanan is a teacher, photographer and musician based in London. In 2012 he started a long-term documentary project about a vulnerable group of people who gravitate towards a corner of east London called Gillett Square. This ongoing work continues to be the core of his practice.

Arpita Shah is a photographic artist exploring the fields where culture and identity meet. Born in India, Arpita spent the earlier part of her life living between India, Ireland and the Middle East before settling in the UK. This migratory experience is reflected in her practice, which often focuses on the notion of home, belonging and shifting cultural identities.

Marie Smith is a visual artist and writer from London. Her practice incorporates digital and analogue photography and text as a form of visual language. Marie was awarded National Lottery grant funding by the Arts Council for her project 'Whispering for Help', which documents the mental health and wellbeing of women of colour.

Ilisa Stack is a photographer based in Glasgow, Scotland, who uses social documentary and environmental portraiture as a means of visual storytelling. Her projects explore themes of youth culture, and community and social change and include 'Oot tae Play', which focuses on documenting Glasgow children beyond digital or online family albums.

Lisa Wormsley is a music and documentary photographer and filmmaker. Her work has been exhibited and published widely, including at the Guardian Gallery and Goldsmiths Centre for Contemporary Art, in conjunction with lectures on disability and austerity. She is part of the collective Ill Considered and is currently working on multiple music/art installations exploring transitional space and isolation.

Fiona Yaron-Field is a London-based photographer and psychotherapist. Her photographic practice combines image and text, her subjects are intimate and familiar, and her approach is collaborative. Through deeply personal material she aims to comment and reflect on wider social and cultural issues.

PHOTOGRAPHER: PAUL SNG

"The portraits and stories in this book explore and celebrate the complex identities that make up modern Britain's story. They draw from our individual and collective past, but perhaps most importantly, together they point to a hopeful future."

JOHN DOMOKOS, VIDEO JOURNALIST, THE GUARDIAN

"With its poignant and timely first-person testimonies by people from wide-ranging, diverse cultural socio-economic backgrounds, alongside celebratory and engaging portraits by some of our leading photographers, This Separated Isle *presents much needed perceptive accounts of the complexities of life in the UK today."*

ANNE MCNEILL, DIRECTOR, IMPRESSIONS GALLERY, BRADFORD

PHOTOGRAPHER: ROBERT LAW

PHOTOGRAPHER: PAUL SNG

"This book comes at a pivotal moment in British history, a history that sees Britain caught between the familiar it still resembles, and the post-Brexit future which awaits it. For that reason, when I look at the faces in this book and at their lives frozen in time, I cannot help but wonder how that future to come will frame them, touch them."

ANDREW JACKSON, PHOTOGRAPHER

"This Separated Isle *serves up a cocktail of provocative photographs and intimate narratives that capture the deep humanity of those caught between worlds of belonging in modern Britain. It's a moving addition to the canon of British diaspora storytelling, at a time of urgent reflection on the nation's jingoistic legacy of empire.*"

JESSIE LAU, WRITER AND JOURNALIST

PHOTOGRAPHER: RHYS BAKER

"Arguments about Brexit, immigration and wokeness are fuelled by the secular decline of imperialism and decades of deindustrialisation. This stunning book of diverse stories and wonderful portraits shows us that removing the imperialist baggage of the UK state presents us with new cultural and political opportunities."

IRVINE WELSH, WRITER

PHOTOGRAPHER: ALICIA BRUCE

PAUL SNG is a biracial British Chinese filmmaker and writer based in Edinburgh, Scotland whose work is driven by methodical research, creative storytelling and a collaborative approach that strives for inclusivity and diversity in people and projects. Paul's documentaries have been broadcast on national television and screened internationally and include *Dispossession: The Great Social Housing Swindle* (2017) and *Poly Styrene: I Am a Cliché* (2021).

Also available in this series: *Invisible Britain: Portraits of Hope and Resilience.*

 @paulsng paulsng1

Even as COVID-19 made a seismic impact across the world, the cracks exposed by Brexit, Black Lives Matter and rising levels of race hate crimes revealed bitter divisions in British society. In the aftermath of the pandemic, and with questions over the breakup of the United Kingdom refusing to dissipate, how do people across Britain choose to navigate the tensions in this divided land? *This Separated Isle* explores how concepts of 'Britishness' reveal an inclusive range of opinions and understandings about our national character. Featuring a diverse range of fascinating photographic portraits of people from across the UK and their accompanying narrative stories, the book examines the relationship between identity and nationhood, revealing not only what divides us, but also the ties that bind us together as a nation.

"This stunning book shows us that removing the imperialist baggage of the UK state presents us with new cultural and political opportunities."

IRVINE WELSH

"These portraits are a battle cry against the intolerant, the bigoted and the ignorant."

PATRICK JONES

"We British folk are all over the place. We come from all over the place, we move all over the place, and our ideas are all over the place. This book reflects that."

BENJAMIN ZEPHANIAH

"A touching, unsettling elegy on modern British identity."

TINA GHARAVI

Policy Press
PUBLISHING WITH A PURPOSE
🐦 @policypress f PolicyPress
policy.bristoluniversitypress.co.uk

ISBN 978-1-4473-5405-5

9 781447 354055